IMAGES
of Rail

THE BALTIMORE & OHIO RAILROAD IN MARYLAND

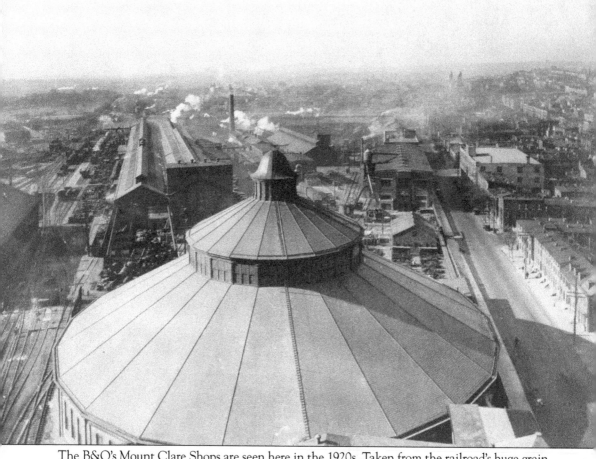

The B&O's Mount Clare Shops are seen here in the 1920s. Taken from the railroad's huge grain elevator, this west-facing photograph gives a sense of the sheer size of the railroad's operations. Dating to the beginning of railroading, the shops were essential to the B&O and helped build Baltimore. While many of these buildings no longer exist, the iconic roundhouse serves as the home of the B&O Railroad Museum. (Courtesy of the B&O Railroad Museum.)

ON THE COVER: B&O F7A No. 4533 and a B-unit are seen on the turntable at the Cumberland Yards in the late 1950s. Diesel power revolutionized railroading, and the B&O's Cumberland Shops serviced and maintained both steam and diesel engines. Today, CSX, the successor to the B&O's physical legacy and its cultural heritage, maintains facilities in Cumberland. (Courtesy of the B&O Railroad Museum.)

IMAGES
of Rail

The Baltimore & Ohio Railroad in Maryland

David Shackelford

ARCADIA
PUBLISHING

Published by Arcadia Publishing
Charleston, South Carolina

Library of Congress Control Number: 2013949190

For all general information, please contact Arcadia Publishing:
Telephone 843-853-2070
Fax 843-853-0044
E-mail sales@arcadiapublishing.com
For customer service and orders:
Toll-Free 1-888-313-2665

Visit us on the Internet at www.arcadiapublishing.com

*To my children, Abigail and Carter, for being willing
participants in my historical pursuits.*

CONTENTS

ACKNOWLEDGMENTS

The B&O Railroad Museum's vision is to preserve the physical legacy of American railroading and to interpret and present its history to the widest audience. This vision is possible because of the tremendous resources available to staff and researchers at the museum's Hays T. Watkins Research Library. The library contains over 200,000 images and countless documents related to every aspect of railroading, from its inception in 1827 to today. I have been fortunate to work with the collection for over a decade, and it is truly iconic and extensive. Truth be told, there are many gems yet to be uncovered in its incredible holdings.

Besides a world-class collection, the museum has a dedicated staff, both past and present, that helps those interested utilize these resources. I am thankful for their support; without their assistance, this project would not have been possible. I personally thank Sarah Davis, Jane Harper, John Maranto, Ryan McPherson, Janelle Ryder, and executive director Courtney Wilson. Unless otherwise noted, all images in this book were provided by the B&O Railroad Museum's Hays T. Watkins Research Library. I also wish to thank my editor at Arcadia Publishing, Julia Simpson, for her gentle reminders and guidance during the process. Finally, to my wife, Karyn: thank you for your editorial surveillance and patience during the process.

INTRODUCTION

The Baltimore & Ohio Railroad (B&O) is one of the most significant railroads in American history. While not the first railroad in the United States, it was the first to offer regular passenger and freight service. Dating to the beginning of railroading, it began operations in 1830 with just 13 miles of track. To put this in perspective, though, there was only 23 miles of track in the entire country, competing with over 3,000 miles of canals and thousands of miles of roads and turnpikes. All 13 miles were in Maryland, and from its inception, the B&O was one of Maryland's most important businesses ventures. Baltimore was the center and headquarters of the B&O. From the port city, the railroad laid a network of iron and steel that crossed the state and would eventually link 13 Northeastern and Midwestern states and the nation's capital.

The B&O received its name from its point of origin, Baltimore, and its intended destination, the Ohio River Valley. Formed in February 1827, it broke ground on July 4, 1828, and began regular operations from Baltimore to Ellicott's Mills on May 24, 1830. It was truly a pioneering railroad, as no line had ever been constructed through the rough terrain and mountains of western Maryland. The railroad would face many challenges, but its pioneering efforts led the *American Railroad Journal* to call the B&O "the Railroad University of the United States."

From the beginning, the B&O made decisions that impact railroading to this day, including the decision to build many early structures from granite. This included bridges and depots. Several of these structures still exist, and some continue to carry CSX trains. Structures like the Ellicott City depot and the Carrollton and Thomas Viaducts are recognized as national historic landmarks, for both engineering and artistic aspects of their design and construction.

Baltimore grew with the B&O. Its Mount Clare Shops provided the industrial strength needed to build and maintain this regional powerhouse, employing hundreds and eventually thousands of workers. The city's stations were highly utilized commuter and freight stations supporting the growth of the local economy and industry. Some of these still exist, including Mount Clare Depot, Camden Station, and Mount Royal Station. The B&O's port facilities are still in use today. Locust Point and Curtis Bay were used by the B&O to export natural resources from the Midwest and goods from all along the B&O's line and to import goods and produce. These are now owned by CSX and used to export coal and freight. The railroad's Riverside yards serviced B&O engines and are now owned by Bombardier and used to maintain the passenger cars and engines used to operate the Maryland Area Rail Commuter (MARC) service.

The B&O's major branch lines in Maryland were the Washington branch and Metropolitan branch. Both offered routes into Washington, DC. The Washington branch, completed in 1835, was the most important rail line in America at the outbreak of the Civil War. The Metropolitan branch, completed in 1873, provided a more direct route to the B&O's western destinations. Both branches served as the primary passenger lines for the B&O, carrying many of the named trains, such as the Royal Blue, Capitol Limited, and National Limited. The tradition continues today, as both Amtrak and MARC trains operate over these lines.

The surrounding network of passenger and freight stations constructed by the B&O served a growing community and was the focal point for economic development in the region. Initially serving farms, mills, and small towns, the stations served as the catalyst for suburban growth as communities replaced farmland and grew into commuter stops. While many no longer exist, others dot the landscape. A few are still used for modern commuter service, others as museums or community centers.

The B&O was a cog in Maryland's economy, providing critical shipping points for commerce and routes for travel. It was one of the largest local employers, and its stations were the backdrop of everyday drama that took place in waiting rooms and on platforms.

Besides being a local powerhouse, the railroad served as an active player at significant times in America's history. During the Civil War, the railroad's infrastructure was attacked and damaged throughout the war, but the railroad proved to be an iron road to victory, hauling tons of supplies and thousands of soldiers. Labor issues and economic panic culminated in the devastating strikes of 1877, forcing changes from management. The railroad threw itself a party for the ages in 1927 to celebrate the 100th anniversary of the B&O and railroading in America.

Even the ultimate demise of the railroad mirrored the industry. Failure to adapt to the post–World War II economy, the rise of competition from other forms of transportation, intense regulation, and mismanagement made the B&O a ripe target for merger and acquisition. In 1963, the Chesapeake & Ohio Railway purchased controlling interest in the B&O. It merged with the Western Maryland and became part of the Chessie System in 1971, and it merged again with Seaboard System of CSX. An era officially ended as the B&O ceased to exist in 1987.

The intent of this book is to provide a broad graphic history of the B&O in Maryland. Given the lengthy and significant history of the railroad, and its impact to the region, this book is not all-inclusive. But it does give a glimpse of the impact the railroad had on the region.

One

THE FIRST 13 MILES
1827–1830

The Baltimore and Ohio Railroad (B&O) was the product of competing business interests and changes in transportation in the early 19th century. The port of Baltimore feared the loss of business from competition with cities like Boston, Philadelphia, New York, and Charleston. Efforts to exclude Baltimore from the proposed Chesapeake & Ohio Canal would persuade local leaders to look to England and import railroad technology that would transform Maryland and eventually the United States.

Merchants and entrepreneurs met in February 1827 to discuss and then decide to build a railroad. They received their charter from the Maryland Legislature, and the railroad was incorporated on February 28, 1827. Stock subscriptions raised the capital funds necessary to begin construction and formally organize the railroad. Engineers and surveyors began the work of laying out a potential route west that would ultimately head southwest from the city to join the Patapsco River Valley and westward up the Potomac River Valley.

Railroading in its infancy was truly a matter of trial and error. No one had constructed a railroad that would cross the incredibly diverse geography of Maryland, including the mountains in the western section of the state. Ground-breaking ceremonies took place on July 4, 1828, as construction formally began on the first 13 miles of the B&O. Beginning in Baltimore, the line would stretch to Ellicott's Mills, Maryland, home to mills and situated on the Baltimore & Frederick Turnpike. Trains began operations to Ellicott's Mills on May 24, 1830, marking the beginning of an incredible journey that would last more than 150 years.

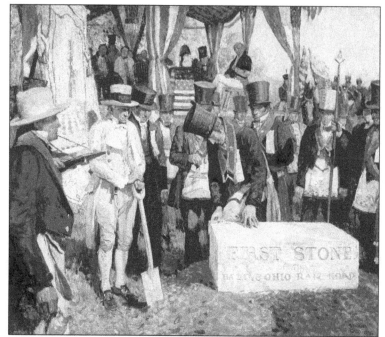

Charles Carroll of Carrollton, the last living signer of the Declaration of Independence and a B&O board member, sets the first stone of the B&O on July 4, 1828. The ceremony capped a parade through the city witnessed by more than 50,000 people. Made of granite, the stone contained a copy of the charter and newspapers of the day. It was placed in the ground until being uncovered in the 1890s.

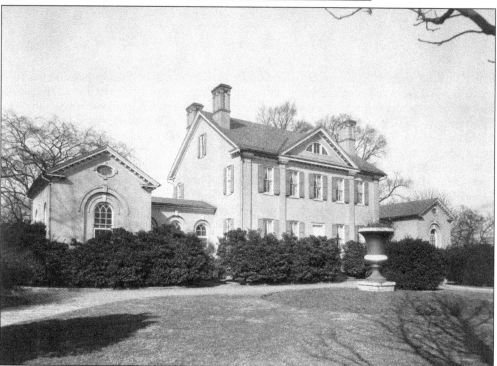

In 1828, James Carroll donated 10 acres of land on the northeast corner of his plantation to the B&O. Carroll hoped the B&O would serve his docks, located in the Patapsco River basin. In the end, the railroad selected nearby Baltimore. Charles Carroll the Barrister, a distant relative of Charles Carroll of Carrollton, built Mount Clare mansion (shown here) in the 1750s. The railroad's shops were named after this mansion and estate.

The B&O Railroad issued stock to pay for the massive undertaking of building a railroad to the Ohio River. The state of Maryland and Baltimore City invested heavily to support what they hoped would be a successful business venture. The railroad reached the Ohio River in December 1852, stretching approximately 380 miles from Baltimore at a cost of over $15 million.

The B&O hired Caspar Wever as superintendent of construction to supervise contractors and oversee completion of tracks and structures. A no-nonsense individual, Wever had gained his experience working on portions of the National Road. He was a controversial figure who favored stone and granite construction methods, which raised the cost to build the railroad and almost bankrupted the B&O.

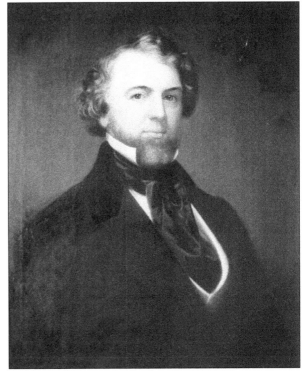

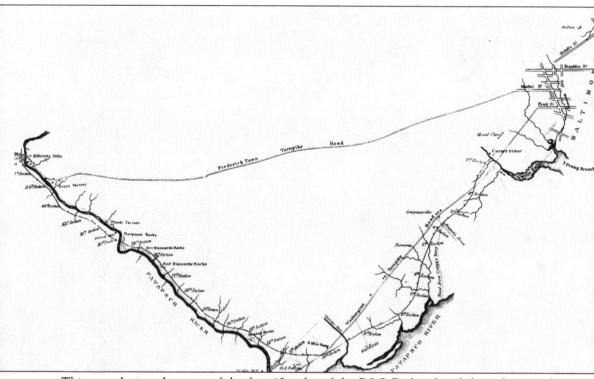

This map depicts the route of the first 13 miles of the B&O Railroad and shows how track construction was split into sections for contractual purposes. The line headed southwest from Baltimore until it reached the Patapsco River Valley, which it followed westward to the bustling community of Ellicott's Mills. The map also shows the Baltimore & Frederick Turnpike, which took a more direct route than the railroad to Ellicott's Mills.

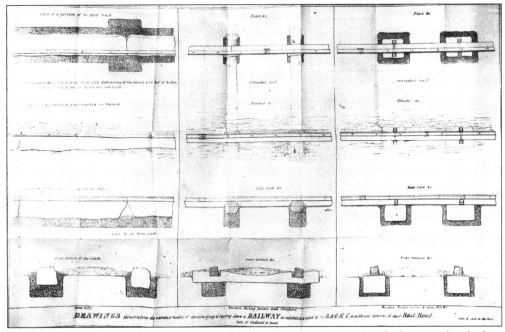

The B&O initially used three variations of railroad track. One consisted of strap rail spiked on granite, 16 inches wide and 12 inches high, cut into seven-foot-long sections laid end-to-end. A second method consisted of strap rail spiked to wooden stringers, fastened to granite blocks laid opposite each other. The third method utilized strap rail attached to longitudinal wooden stringers, 12 to 40 feet long, placed upon wooden crossties.

The Carrollton Viaduct was named after Charles Carroll of Carrollton when it was completed in 1829. The bridge, which carried the railroad over the Gwynns Falls, was more than 300 feet in length and approximately 60 feet high. This lithograph was one of a series of images created in 1831 by Endicott & Swett depicting structures of the B&O.

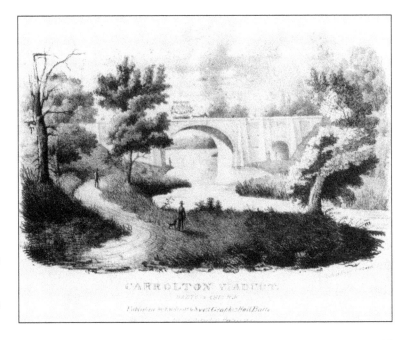

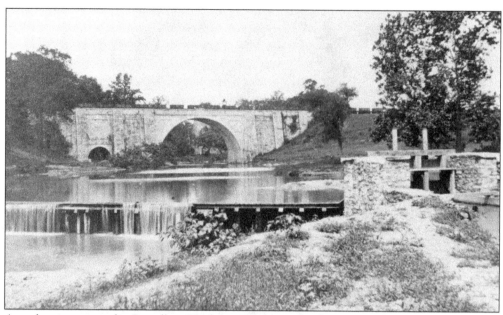

A coal train crosses the Carrollton Viaduct in the post–Civil War era. The Carrollton Viaduct is the oldest railroad bridge in America and is still in use today. Its continued use is a testament to its design. When railroading began, the span carried horse-drawn cars that weighed less than three tons. Today's CSX locomotives can weigh close to 200 tons!

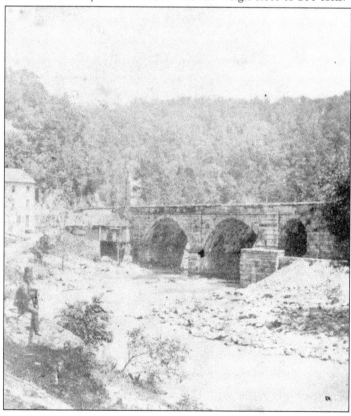

Completed in 1829 and named after B&O director William Patterson, the Patterson Viaduct crossed the Patapsco River near Ilchester, Maryland. It was 375 feet long and, like many early B&O stone bridges, it was constructed from granite mined from quarries near Ellicott's Mills, Maryland (now known as Ellicott City). Portions of it were washed away in the flood of 1866, and it was replaced with an iron truss span.

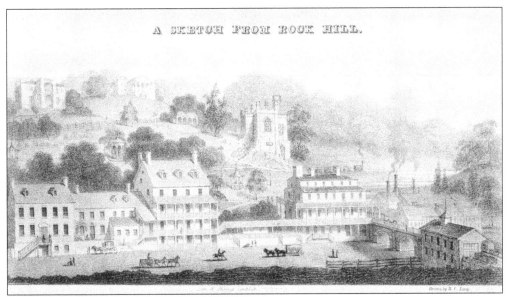

This drawing shows, at lower right, the Ellicott's Mills depot in 1833. Note the two doors on the side of the depot that allowed railcars and, eventually, small steam engines to be pulled directly into the building for servicing and storage. Steam ports would be added for steam-engine storage. Soot can still be seen on the interior walls of the carhouse today. (Courtesy of the Maryland Historical Society.)

In its early days, the B&O used horses to pull its cars and trains until it could find more powerful and reliable steam engines. In a parade at an unknown location, the B&O's first driver makes his way along the tracks, as he once did. While his name is not given, he is listed as 91 years old.

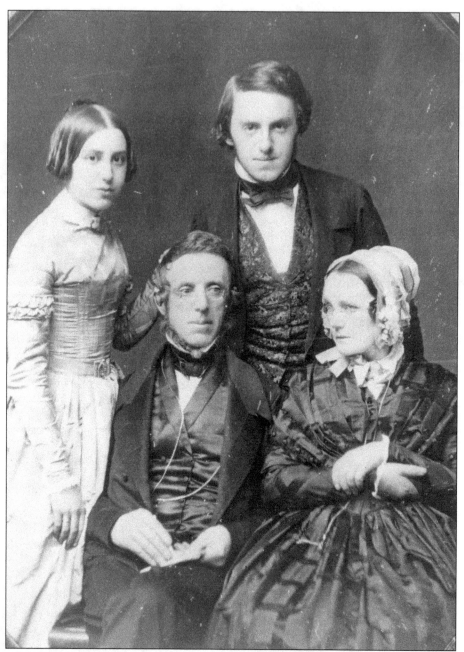

Peter Cooper (seated) was an inventor and philanthropist from New York. He is known for building the first American-made steam locomotive. Known as the "Tom Thumb," it was an experimental engine that was never used in regular service. Cooper won a contract to construct additional engines for the railroad; however, he failed to do so. He held many patents, including one for gelatin that would be sold to a company that created instant gelatin, more commonly known as Jell-O. He formed a college, the Cooper Union, in the 1850s, with the premise that a college education should be free. Today, the Cooper Union is recognized as one of the leading American colleges in the fields of architecture, engineering, and art. Also shown here are his wife, Sarah (right), his daughter, Sarah, and his son, Edward.

16

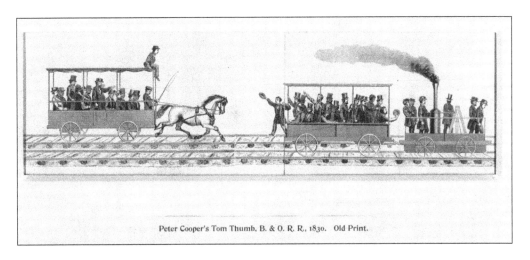

Peter Cooper's Tom Thumb, B. & O. R. R., 1830. Old Print.

Here are two views of the famous race between a horse-drawn car and the "Tom Thumb." As the rumor goes, the Tom Thumb came upon a horse-drawn car on a return trip from Ellicott's Mills, and a race ensued. The horse is supposed to have won because the Tom Thumb broke down. No direct evidence has ever been found to determine if the race actually took place. In fact, the first details of the story came from a speech by Benjamin Latrobe in 1868. While the truth may never be known, the story serves to emphasize a period in America's history of profound change, during the Industrial and Transportation Revolutions in the early 19th century. The above image is from an early woodcut of the race. Below is a painting completed by Herbert Stitt in 1926.

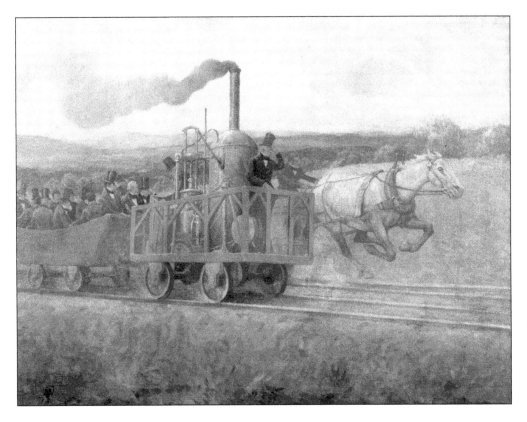

Stagecoach builder Richard Imlay created passenger cars made from modified stagecoach bodies placed on a frame with flanged wheels. The coaches were unique in the early days of horse-drawn service, allowing passengers to sit above or inside the coaches. The arrangement was not ideal with the advent of steam engines due to flying soot and cinders. The more recognizable day coach quickly evolved to take their place.

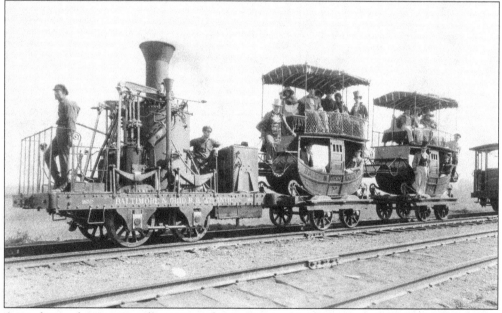

A grasshopper locomotive pulls two reproduction cars in this 1920s re-creation of an early passenger train. The engine being used is labeled "the Atlantic." It is actually the *Andrew Jackson*, built at the Mount Clare Shops in 1836 by Ross Winans and George Gillingham. Small engines such as this were known as grasshoppers because the up-and-down motion of the rods and pistons reminded people of insects.

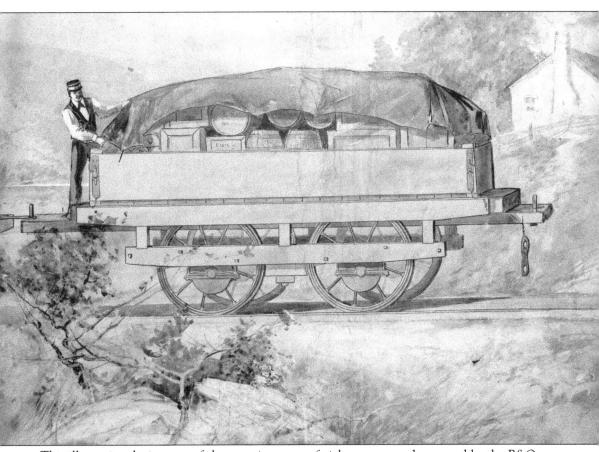

This illustration depicts one of the most important freight cargoes and cars used by the B&O Railroad in the 1830s. This car carried barrels of flour from the industrial center of the Patapsco River Valley and would prove to be highly profitable. Millers like the Ellicotts of Ellicott's Mills donated land and served on the board of the B&O to protect their interests and benefit from the railroad.

AMERICAN

AND COMMERCIAL DAILY ADVERTISER.

BALTIMORE:

FRIDAY MORNING, MAY 21, 1830.

PUBLISHED EVERY MORNING BY
DOBBIN, MURPHY & BOSE,
NO. 2, SOUTH GAY STREET.

We stated in yesterday's *American* that the Rail-road would be opened for travelling between this city and Ellicotts' Mills on Monday next, the 24th instant, and we have now the pleasure of publishing an official annunciation of the fact. This information, we are assured, will be received with sentiments of unmingled satisfaction by our fellow citizens, and also by the friends of internal improvement in every part of the Union. When a *practical* experiment on so extended a scale is so soon to be hourly exhibited, it is scarcely worth our while to speak of its results in anticipation, but we will nevertheless venture to assert that it will prove perfectly satisfactory to every one who visits the Road, and establish conclusively the fact of the superiority of this mode of intercourse and trade over every other.

Office of the Baltimore and Ohio Rail-road,
20th May, 1830.

NOTICE IS HEREBY GIVEN, That the Rail-road between Baltimore and Ellicotts' Mills will be opened for the transportation of passengers, on MONDAY, the 24th instant.

A brigade, or train of coaches, will leave the Company's Depot on Pratt-street, and return, making three trips each day—starting at the following hours precisely, viz:—

Leave Baltimore at 7 A. M. and Ellicotts' at 9 A. M.
" 11 A. M. " " 1 P. M.
" 4 P. M. " " 6 P. M.

The price for the trip of twenty-six miles, will be seventy-five cents for each person. Tickets to had at the Depot. Should the demand be found to exceed the present means of accommodation, passengers will be under the necessity of going and returning in the same coach, until a sufficient additional number of carriages can be furnished. As soon as this can be effected, of which due notice will be given, provision will be made for travelling a shorter distance than the whole trip. P. E. THOMAS, President

Baltimore and Ohio Rail-road Company.

May 20, 1830. d3t

☞The editors of the National Intelligencer and Telegraph, Washington, will publish the above three times.

The *American and Commercial Daily Advertiser* announced the first scheduled trains on the B&O line on May 21, 1830. Trains began operation on Monday, May 24, 1830, departing three times a day from the Pratt Street depot and running to the end of the line at Ellicott's Mills. The 26-mile round-trip cost 75¢. Although the schedule gives three departure times, it is important to note that the B&O operated trains in convoys. This meant that one "train" could consist of several horse-drawn trains traveling one after the other heading to Ellicott's Mills.

Two

THE B&O GROWS
1830–1865

From the B&O's uncertain beginnings, the railroad would grow to be a regional power and play a key role in the American Civil War. During this time, the railroad opened a branch line to Frederick (1831), to Washington (1835), and reached its stated goal of the Ohio River at Wheeling, Virginia (now located in West Virginia), in December 1852. From its initial 13 miles, the B&O operated 382 miles by the end of the war, with stops throughout Maryland, Virginia, West Virginia, and Washington, DC.

The B&O's route through Maryland touched major cities and small towns, encouraging growth and providing the impetus of economic development by moving people and goods along its lines. What is commonly referred to today as the "Old Main Line" was initially known as the main stem. Well-known stations opened at Ellicott's Mills, Sykesville, Mount Airy, Point of Rocks, and Cumberland. Passenger service flourished along its route, serving commuters, immigrants, and long-distance travelers. Freight expanded, and Baltimore benefited the farther west the line reached. It hauled natural resources, such as coal, through the port. Technology advanced as well, as locomotives became more powerful and the early grasshopper locomotives were relegated to yard service.

When the Civil War began, the B&O was the most important rail line in the region. Situated along Maryland and Virginia, its business interests served both North and South. The Washington branch was the only route from the north into the capital, and its line west carried vital natural resources. It was the quickest and most direct route to the Ohio River Valley. Both lines were essential to holding the Union together. The railroad would be constantly disrupted and guarded throughout the war. It was so important that it would eventually be known as "Mr. Lincoln's railroad."

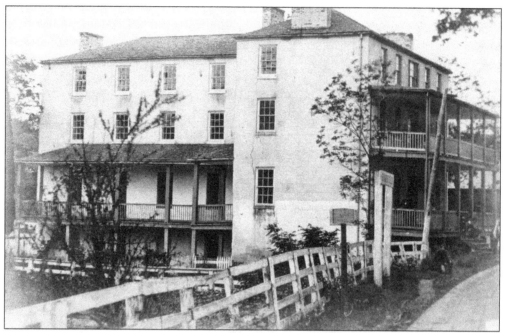

In the early days of railroading, the B&O partnered with existing businesses to sell or allow B&O agents to sell passenger tickets. Trains would stop at locations like Sykes Tavern, in present-day Sykesville. James Sykes built a hotel specifically to cater to railroad business, and Sykesville, like many other towns along the line, would grow with the coming of the railroad.

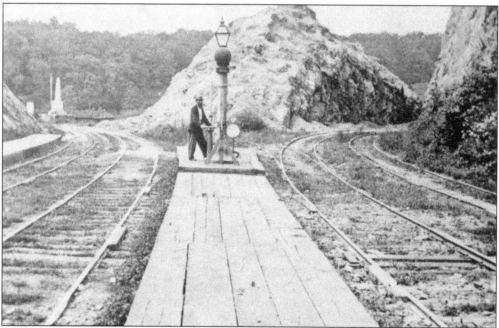

A signalman waits next to a signal stand west of the Relay Hotel at Relay, Maryland. It was here that the B&O's Washington branch separated from the main line and headed south across the Thomas Viaduct. The tracks to the left turn toward the viaduct and pass the monument to the workers who constructed the bridge. The main stem continues west on the tracks to the right.

Completed in 1835, the Thomas Viaduct crosses the Patapsco River at Relay and Elk Ridge, Maryland. Designed by Benjamin Latrobe, it is named after B&O president Philip Thomas. The bridge spans over 600 feet and stands about 60 feet above the water. It cost $142,236 to construct and was made from granite quarried in the Patapsco River Valley. A monumental accomplishment, it is still in use today.

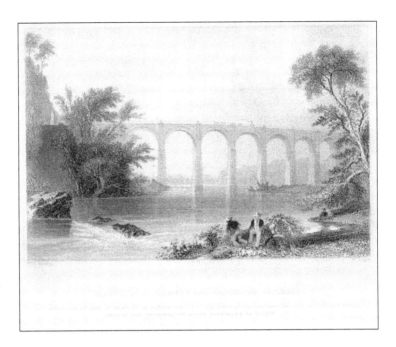

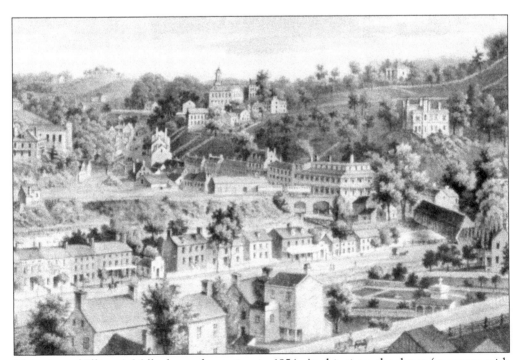

This view of Ellicott's Mills shows the station in 1854. At this time, the depot (at center, with two passenger cars in front of it) was a freight-only facility. The station would be modified to also serve passengers in 1857. The road in the foreground, the Baltimore & Frederick Turnpike, runs uphill under the B&O's Oliver Viaduct. (Courtesy of the Maryland Historical Society.)

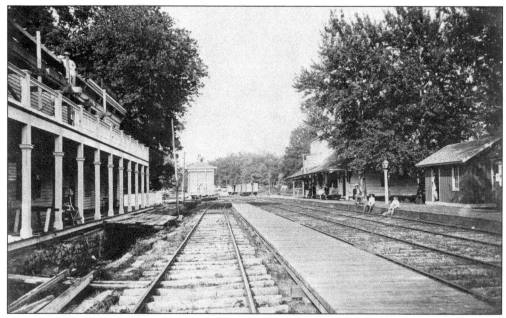

This 1860s photograph shows Annapolis Junction and the platforms and hotels serving railroad travelers. This is where the B&O connected to the Annapolis & Elk Ridge Railroad and provided rail access to the state capital of Annapolis. The connection proved crucial to the nation during the early days of the Civil War. Union officials used the junction to transport soldiers from Annapolis to Washington, circumventing Baltimore.

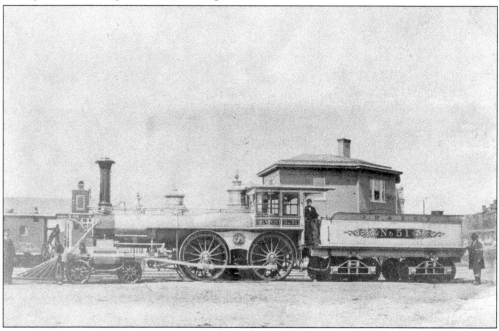

The Philadelphia, Wilmington & Baltimore's No. 51 *Phantom* sits in front of the Mount Clare depot in the 1850s. The locomotive was a classic "American-type" engine used on many passenger lines at the time of the Civil War. Mount Clare depot appears as it did prior to the construction of the 1884 roundhouse.

Service to Frederick on the Frederick branch began in December 1831. The original depot (pictured above), similar in design to the Ellicott's Mills station, was built in 1832. It had door access for railcars to enter the building, and it continued to be used as a separate freight depot into the early 1900s. The 1854 passenger station (below) was located on the corner of All Saints and South Market Streets. Pres. Abraham Lincoln's train stopped here in October 1862 after the bloody battle of Antietam. Lincoln gave an impromptu speech from the back of a passenger car to the waiting crowd, thanking the citizens of Frederick.

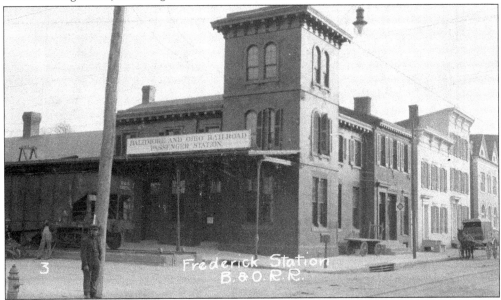

BALTIMORE & OHIO RAILROAD.

Thos. Swann, Pres. Baltimore. Md. Wm. Parker, Supt., Baltimore.

Miles	Fares	BALTIM'E CUMBERL	1st Tr'n	2d Tr'n	Exs. Tr'n
		TRAINS LEAVE	A.M.	P.M.	P.M.
		Baltimore*.	8 00	4 15	11 00
1		Mount Clare	8 15	4 30	---
9	25	Relay H'se†	9 35	4 55	---
10	37	Avalon......			---
13	50	Ilchester ..	9 00	5 16	---
15	56	Ellicott's M.	9 16	5 34	---
21	85	Elysville....	9 25	5 45	---
25	1 00	Woodstock .	9 33	5 53	---
29	1 15	Marriottsv'e	9 50	6 10	---
32	1 25	Sykesville..	10 53	6 14	---
35	1 40	Hood's Mill.	10 15	6 36	---
38	1 50	Woodbine...	10 30	6 50	---
44	1 75	Mount Airy.	10 40	7 00	---
50	2 00	Monrovia...	10 55	7 12	---
54	2 15	Ijamsville..	11 07	7 25	---
59	2 35	Monocacy..	11 25	7 45	---
		Monoca'y	11 30	7 45	
3	15	Frederick	12 00	8 15	
63	2 50	Buckeysto'n	11 33		---
65	2 60	Davis' W. H.			---
70	2 80	Point of Rks	11 48		---
72	2 90	Catoctin Sw.			---
76	3 05	Berlin......	12 05		---
79	3 15	Knoxville...			---
80	3 20	Weverton...	12 25		---
82	3 30	Harper's F§	12 55		---
88	3 50	Duffields....	1 12		---
93	3 70	Kearneyville	1 25		---
101	4 00	Martinsb'g.	1 50		---
104	4 15	Tabbs......			---
108	4 30	Hedgesville..	2 10		---
117	4 70	Licking W.S	2 35		---
124	5 00	Hancock....	2 52		---
130	5 15	Sir John's R.	3 07		---
133	5 30	Gr't Cacapon	3 20		---
142	5 70	D. G. Tunnel	2 37		---
151	6 05	No.12 W. Sta	4 02		---
154	6 15	Paw Paw...			---
159	6 30	Lit. Cacapon	4 20		---
163	6 50	South Br'ch.			---
165	6 60	Gr'n Sp.Run	4 40		---
171	6 85	Patterson's..	4 55		---
179	7 00	Cumb'rland	5 15		

Miles	Fares	CUMBERL BALTIME	1st Tr'n	2d Tr'n	Exs. Tr'n
		TRAINS LEAVE	A.M.	A.M.	P.M.
		Cumb'rland	8 00		10 00
8	25	Patterson's.	8 20		---
14	50	Gr'n Sp.Run	8 35		---
16	60	South Br'ch.			---
21	70	Lit. Cacapon	8 53		---
25	85	Paw Paw....			---
28	95	No.12 W. Sta	9 10		---
37	1 30	D. G. Tunnel	9 42		---
46	1 70	Gr't Cacapon	10 00		---
49	1 85	Sir John's R.	10 15		---
55	2 00	Hancock....	10 28		---
62	2 30	Licking W.S	10 45		---
71	2 70	Hedgesville..	11 10		---
75	2 85	Tabbs......			---
78	3 00	Martinsb'g.	11 30		---
86	3 30	Kearneysv'e	11 53		---
91	3 50	Duffield's...	12 06		---
97	3 70	Harper's F§	1 00		---
99	3 80	Weverton...	1 05		---
100	3 85	Knoxville...			---
103	3 95	Berlin......	1 25		---
107	4 10	Catoctin Sw.			---
109	4 20	Point of Rks	1 50		---
114	4 40	Davis' W. H.			---
116	4 50	Buckeysto'n	2 07		---
		Frederi'k	1 45	7 30	
3	12	Monoca'y	2 15	7 55	
120	4 65	Monocacy...	2 20	7 55	---
125	4 85	Ijamsville...	2 32	8 05	---
129	5 00	Monrovia...	2 45	8 25	---
135	5 25	Mount Airy.	2 58	8 35	---
141	5 50	Woodbine...	3 10	8 50	---
144	5 60	Hood's Mill.	3 22	9 05	---
147	5 75	Sykesville..	3 42	9 30	---
150	5 85	Marriottsv'e	3 52	9 50	---
154	6 00	Woodstock..	4 02	10 00	---
158	6 15	Elysville....	4 15	10 08	---
164	6 50	Ellicott's M.	4 25	10 18	---
166	6 50	Ilchester....	4 42	10 35	---
169	6 65	Avalon......			---
170	6 75	Relay H'se†	5 00	10 55	---
178	7 00	Mount Clare	5 20	11 15	---
179	7 00	Baltimore*.	5 30	11 25	---

* For List of Railroads diverging from Baltimore, see page 27.
For remainder of Notes of this Road, see bottom opposite page.

The railroad's 1840s timetable was included in *Appleton's Railroad and Steamboat Companion*. When the guide was printed, the B&O had reached Cumberland, Maryland, a distance given as 179 miles from Baltimore. The entire journey took an incredible 9 hours and 15 minutes, at a cost of $7. The average rate of speed was a little over 19 miles an hour, which included stops for watering, fuel, and food. The guide, and others like it, provided useful information on times and rates. In addition, it included railroads that connected with the B&O and information on the Frederick and Washington branches. It also included information on stagecoach lines, steamboats, and packet steamers. As is the case today, early long-distance travel often required several forms of transportation to complete the journey.

LOCOMOTIVES
ON THE
Main Stem and Washington Branch of the
BALTIMORE AND OHIO RAILROAD,
During the year ending September 30, 1850.

NO. OF ENGINE.	NAME OF ENGINE.	BUILDER'S NAME.	WHEN PLACED ON THE ROAD.	NO. OF ENGINE.	NAME OF ENGINE.	BUILDER'S NAME.	WHEN PLACED ON THE ROAD.
1	ARABIAN,	Phineas Davis,	July, 1834.	35	BUFFALO,	Ross Winans,	Nov. 1844.
2	GEO. WASHINGTON,	" "	Oct. 1834.	36	BALTIMORE,	" "	Dec. "
3	THOS. JEFFERSON,	" "	June, 1835.	37	CUMBERLAND,	" "	July, 1845.
4	JAMES MADISON,	" "	" "	38	ELEPHANT,	" "	" "
5	JAMES MONROE,	" "	" "	39	REINDEER,	" "	Dec. "
6	J. Q. ADAMS,	" "	July, "	40	OPEQUAN,	" "	July, 1846.
7	A. JACKSON,	" "	Feb'y, 1836.	41	ELK,	" "	Aug. "
8	JOHN HANCOCK,	Gillingham & Winans,	April, "	42	CATOCTIN,	" "	Oct. "
9	PHINEAS DAVIS,	" "	Aug. "	43	YOUGHIOGHENY,	" "	Nov. "
10	GEORGE CLINTON,	" "	" "	44	BALDWIN,	M. W. Baldwin,	Nov. "
11	M. VAN BUREN,	" "	Nov. "	45	TUSCARORA,	Ross Winans,	Dec. "
12	BENJ. FRANKLIN,	" "	April, 1837.	46	ALLEGANY,	" "	" "
14	WILLIAM PATTERSON,	" "	June, "	48	DELAWARE,	New Castle Co.,	Jan. 1847.
16	P. E. THOMAS,	Wm. Norris,	" 1838.	49	MOUNT CLARE,	B. & O. R. R.	May, "
17	MAZEPPA,	Gillingham & Winans,	Oct. "	50	WISCONISCO,	M. W. Baldwin,	Dec. "
19	WM. COOK,	Wm. Norris,	Dec. "	51	DRAGON,	" "	Jan. 1848.
20	PATAPSCO,	" "	July, 1839.	52	JUNO,	Ross Winans,	" "
21	MONOCACY,	" "	" "	53	UNICORN,	M. W. Baldwin,	Feb. "
22	POTOMAC,	" "	Aug. "	54	HERO,	B. & O. R. R.	May, "
23	ATLAS,	Eastwick & Harrison,	Sept. 1839.	55	CAMEL,	Ross Winans,	June, "
24	PEGASUS,	Wm. Norris,	Nov. 1839.	56	SATURN,	New Castle Co.	" "
25	VESTA,	" "	" "	57	MEMNON,	" "	July, "
26	VULCAN,	Eastwick & Harrison,	July, 1840.	58	HECTOR,	M. W. Baldwin,	Oct. "
27	JUPITER,	" "	Feb'y, "	59	IRIS,	Ross Winans,	Dec. "
29	MERCURY,	" "	July, 1842.	60	COSSACK,	M. W. Baldwin,	" "
30	MINERVA,	" "	Feb. "	61	MARS,	Ross Winans,	" "
31	STAG,	Wm. Norris,	May, 1843.	62	TARTAR,	M. W. Baldwin,	Jan. 1849.
32	ATLANTA,	Ross Winans,	Oct. "	63	GIANT,	B. & O. R. R.	May, "
33	HERCULES,	" "	Oct. 1844.	64	LION,	" "	March, 1850.
34	GLADIATOR,	" "	Nov. "				

WASHINGTON BRANCH.

NO. OF ENGINE.	NAME OF ENGINE.	BUILDER'S NAME.	WHEN PLACED ON THE ROAD.	NO. OF ENGINE.	NAME OF ENGINE.	BUILDER'S NAME.	WHEN PLACED ON THE ROAD.
13	LAFAYETTE,	Wm. Norris,	April, 1837.	28	ARROW,	New Castle Co.	Feb. 1840.
15	ISAAC McKIM,	Gillingham & Winans,	May, 1838.	47	NEW CASTLE,	" "	Dec. 1840.
18	JOS. W. PATTERSON,	Wm. Norris,	Oct. "				

An 1850 roster of locomotives used on the B&O's main stem and Washington branch lists 64 engines in service. Many of the early grasshopper locomotives built in the 1830s are still in service at this time. Because locomotives could cost as much as $10,000, a large sum of money for the time, it was in the best interest of the railroad to keep any serviceable locomotive in operational condition. Also interesting to note is that the B&O used many contractors to supply its locomotives. The most notable is Ross Winans, who initially worked for the B&O. He built locomotive shops directly next to the Mount Clare Shops to provide more efficient service to the railroad. Winans would become known for creating "Camel"-style locomotives (so named for the placement of the cab directly on top of the boiler instead of near the back). His disagreements over their design led to a major rift with the B&O.

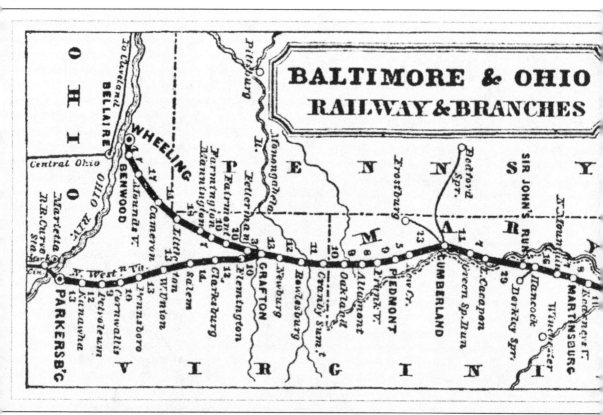

This map shows the route of the B&O in 1860 and its connections to many strategic cities in the region. By the outbreak of the Civil War, the B&O's line stretched west from Baltimore to Wheeling, Virginia, and over a branch line to Parkersburg, Virginia (both now located in West Virginia). The Washington branch headed south from Relay, Maryland, providing the only route

by rail to the nation's capital from the north during the war. From the B&O's Annapolis Junction, the Annapolis & Elkridge Railroad provided service to Maryland's capital. The Philadelphia, Wilmington & Baltimore line provide the northern connection to the B&O between Baltimore, Philadelphia, and, ultimately, New York.

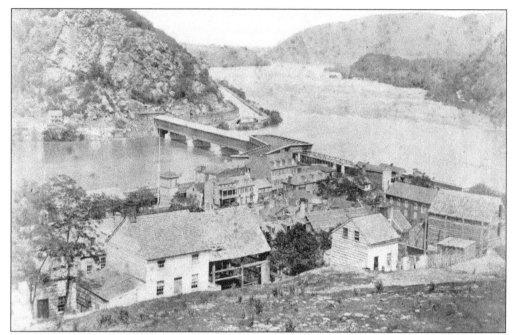

This view from a Harpers Ferry hillside shows the B&O's bridge and road crossing the Potomac River where it meets the Shenandoah River. On the far side is Maryland Heights. The track heads into Maryland, bearing right along the C&O Canal toward Point of Rocks. The bridge is almost entirely in Maryland, since Maryland owns the Potomac River to the Virginia shoreline.

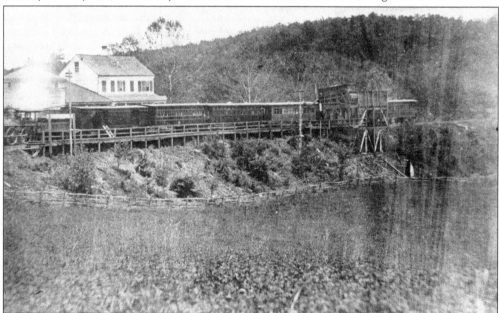

A B&O passenger train stops outside of Frederick Junction in 1858 during the Artist Train excursion. The branch line to Frederick proved instrumental for the growth of the city. Straddling the Baltimore & Frederick Turnpike and the railroad's main line, this branch would be vital to the area during the Civil War. The transportation hub was the focus of the Battle of Monocacy in 1864.

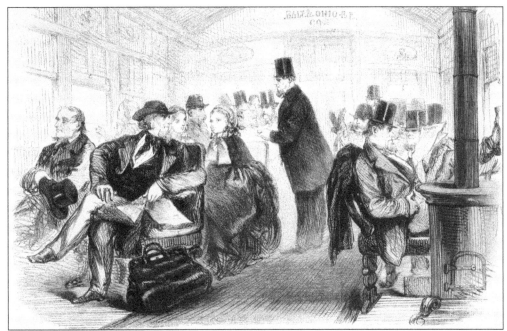

This interior view of a B&O passenger car provides a glimpse of 19th-century rail travel, with all its "comforts." The cars featured plush seats and were enclosed against the elements. They were heated with stoves, and coaches near the front of the train often had problems with soot when the windows were open. The man standing is a conductor, collecting tickets from passengers.

The B&O Railroad provided its employees with rules for operating trains. The page shown here is from an 1856 book that outlined the rules of the road for conductors, engineers, and brakemen. It gave information for the use of whistles and bells for signaling, passing other trains, applying brakes, and managing freight trains. The book was the property of John Shepler, who worked on the Cumberland division.

RULES FOR THE RUNNING OF TRAINS
ON THE
Balt. and Ohio Railroad and its Washington Branch.

SPECIAL INSTRUCTIONS
TO
CONDUCTORS
OF
TONNAGE TRAINS.

1.—Conductors will report themselves daily, and be ready for duty at least three-quarters of an hour before the time specified for starting, which time must be employed in examining their train, brakes, couplings, (and provide an extra number of the latter,) &c.

2.—Every Train, before starting, must be closely inspected (and known to be in good order for running) by the Conductor.

3.—*No train shall start unless the bell-cord is properly attached*, and the lamps in good order. The bell-cord, switch key, flag and lamps, *when lost*, to be supplied by the person losing the same—the amount to be deducted from the wages due at the end of the month.

4.—If the Conductor of a Tonnage Train thinks any car at all unsafe to be run, he shall leave it off from his train, at the first opportunity, unless he be *overruled* by the Supervisor of Trains, a Foreman of Machinery, or an officer still higher than they in rank.

5.—The rule of long standing, and of universal adoption, that no Train may leave a Station before the time prescribed for it in the time table, is to be literally observed, without any exception of train, time, place or circumstances.

6.—The Conductor will on no account start a train on its trip, without having been previously instructed to do so, by the Station Agent, the Despatcher of Trains, or the " Convoy " Conductor.

7.—Every Train, of whatever kind, must be furnished by the Conductor with a bell-cord, passing over the tops of the cars, and connecting the last car with the bell on the Engine or Tender,—for the alarm of the Engineman in case of need—and this cord must remain so attached from the beginning of each trip *to its termination*.

8.—The Conductor or Brakeman must not leave his cars to wind up the bell-rope, *until the Engine has slackened speed to halt at the end of the trip*.

1

TABLE J.

Tabular Statement, shewing the number of Passengers from each Station, upon the Main Stem and Washington Branch of the Baltimore and Ohio Rail Road, during the fiscal year, commencing October 1st, 1847, and ending September 30th, 1848, inclusive.

MAIN STEM.				WASHINGTON BRANCH.			
STATIONS.	Passengers Eastwardly.	Passengers Westwardly.	Total Passengers.	STATIONS.	Passengers Northwardly.	Passengers Southwardly.	Total Passengers.
Baltimore, - -		38,468	38,468	Baltimore, - -		66,824¼	66,824¼
Relay House, -	4,727	3,435	8,162	Relay House, -	7,031¼	6,845¼	13,877
Avalon, - - -	12	110¼	122¼	Elkridge Landing, -	65	32¼	97¼
Ilchester, - -	1,131	94½	1,225½	Jessup's Cut, -	270½	116¼	387
Ellicott's Mills, -	9,721¼	1,606½	11,328	Annapolis Junction, -	3,377	1,029½	4,406¼
Hollowfields, -	18	15½	33½	Savage Rail Road, -	512	184	696
Elysville, -	597	103½	700½	Laurel Siding, -	3,371½	1,509	4,880½
Dorsey's Run, -	18	27	45	White Oak, - -	480	132	612
Woodstock, -	716	150	866	Beltsville, - -	779½	885	1,664½
Marriottsville, -	1,024½	260½	1,285	Paint Branch, - -	306	62	368
Sykesville, - -	1,309	397½	1,706½	Bladensburg, -	915	1,648½	2,563½
Hood's Mill, -	405	140	545	Washington, - -	57,804		57,804
Woodbine, -	491½	187½	679				
Plane No. 1, -	21	2	23				
Mount Airy, - -	581½	182	763½				
Plane No. 4, -	76	9	85				
Monrovia, - -	895½	434	1,329½				
Ijamsville, - -	260	192	452				
Monocacy, - -	225	101½	326½				
Frederick, - -	6,953½	2,577	9,530½				
Buckeystown, -	145½	146½	292				
Davis' Warehouse,	227	107½	334½				
Point of Rocks, -	1,101	612½	1,713½				
Catoctin Switch, -	43½	71	114½				
Berlin, - -	282½	336	618½				
Knoxville, - -	500¼	367½	868				
Weverton, - -	41	38	79				
Harper's Ferry, -	6,851½	5,400½	12,252				
Duffields, - -	244	307	552				
Kearneysville, -	777½	619	1,396½				
Martinsburg, -	1,922	1,370½	3,292½				
Tabb's, - - -	22½	9	31½				
Hedgesville, -	973	375½	1,348½				
Licking Creek, -	30	34	64				
Hancock, - -	634	1,181	1,815				
Sir John's Run, -	1,063½	209½	1,273				
Great Cacapon, -	261	211½	472½				
Doe Gully Tunnell, -	125	151	276				
No. 12 Water Station,	143	266½	409½				
Paw-Paw, - -	237½	506½	744				
Little Cacapon, -	45	200	245				
South Branch, -	84	228	312				
Green Spring Run, -	494	1,069½	1,563½				
Patterson's Creek,	259	487	746				
Cumberland, - -	7,945½		7,945½				
TOTAL,	53,636½	62,799	116,435½	TOTAL,	74,912	79,269	154,181
Phila. to Pittsburg,		9,766½		Baltimore, - -		8,178½	
Balt. to Pittsburg, -		6,913		Washington, -	7,836½		
Phila. to Wheeling,		3,600					
Balt. to Wheeling, -		3,738½	24,018				
Pittsburg to Phila.	7,755½						
Pittsburg to Balt. -	5,016½						
Wheeling to Phila.	4,345						
Wheeling to Balt. -	3,403½		20,520½				
Total Western Passengers, - - -			44,538½	Total Southern Passengers, -			16,015
GRAND TOTALS,	74,157	86,817	160,974	GRAND TOTALS,	82,748½	87,447½	170,196

A table from the B&O's annual report gives passenger traffic totals for the main stem and the Washington branch for the fiscal year running from October 1, 1847, to September 30, 1848. Passenger traffic on the Washington branch was always more significant than that on the main stem and totaled over 154,000 passengers for the year, almost 40,000 more than traveled on the main stem. Baltimore was the leading point of origin for travelers taking both branches. Harpers Ferry and Ellicott's Mills were second and third, respectively, on the main stem. Washington, DC, was the second-busiest point of departure for the Washington branch. These figures emphasize the growth of passenger travel on the line and the importance of these cities to the region, where industrialization and politics played a major role in their significance.

BALTIMORE & OHIO R. R.

MAIN STEM.

CONDUCTOR'S TICKET.

Date ____ 186_

197 S

1 2 3 5 7 9 10 11 13 14 15 16 17
19 21 22 22½ 23 24 25 26 27 28 29
30 31 32 33 34 35 36 37 38 39 40
41 42 44 45 46 47 49 50 51 52

53 54 55 56 57 58 59 60 61 61½ 62 63 64 65
66 67 68 69 70 71 72 73 74 75 76 77 78 79 80
81 82 82½ 83 84 85 86 87 88 89 90 91 92 93 94
95 96 97 98 99 101 102 103 104 105 106 107

Month—1 2 3 4 5 6 7 8 9 10 11 12

10 25 50 75 100

197 S

BALTIMORE & OHIO R. R.

MAIN STEM.

One Seat in First Class Car.

GOOD FOR THIS DAY AND DATE ONLY.

Between the Stations Punched Out.

The presentation of this ticket at any of the ticket offices will entitle the holder to the draw-back NOT PUNCHED OUT.

Good for this day and date only between the Stations Punched Out. CONDUCTOR'S TICKET.

1 Baltimore.	Oakland.	59
2 Washington Junction.	Hutton's.	60
5 Ellicott City.	Cranberry Summit.	61
7 Elysville.	Amblersburg.	61½
9 Woodstock.	Rowlesburg.	62
10 Marriottsville.	Tunnelton.	63
11 Sykesville.	Newburg.	64
13 Hood's Mill.	Independence.	65
14 Woodbine.	Thornton.	66
15 Watersville.	Grafton.	67
16 Mount Airey.	Webster.	68
17 Monrovia.	Simpson's.	69
19 Ijamsville.	Flemington.	70
21 Doe Gully.	Bridgeport.	71
22 Frederick.	Clarksburg.	72
22½ Lime Kiln.	Wilsonburg.	73
23 Buckeystown	Salem.	74
24 Adamstown	Long Run.	75
25 Point of Rocks	Smithton.	76
26 Catoctin.	West Union.	77
27 Berlin.	Central.	78
28 Knoxville.	Toll Gate.	79
29 Harper's Ferry.	Pennsboro'.	80
30 Duffields.	Ellenboro'.	81
31 Kearneysville.	Cornwallis.	82
32 Vanclevesville.	Cairo.	82½
33 Martinsburg.	Petroleum.	83
34 North Mountain.	Walker's.	84
35 Cherry Run.	Kanawaha.	85
36 Sleepy Creek.	Claysville.	86
37 Hancock.	Parkersburg.	87
38 Sir John's Run.	Fetterman.	88
39 Great Cacapon.	Valley Falls.	89
40 Orleans Road.	Nuzum's Mill.	90
41 Doe Gully.	Benton's Ferry.	91
42 No. 12.	Fairmout.	92
43 Paw Paw.	Barnesville.	93
44 Little Cacapon.	Barrackeville.	94
45 South Branch.	Farmington.	95
46 Green Spring Run.	Mannington.	96
47 Patterson's Creek.	Glover's Gap.	97
49 Cumberland.	Burton.	98
50 Brady's Mill.	Littleton.	99
51 Rawlin's W. Station.	Belton.	101
52 Black Oak Bottom.	Cameron.	102
53 New Creek.	Easton's Siding.	103
54 Piedmont.	Roseby's Rock.	104
55 Bloomington.	Moundsville.	
Frankville.	...wood.	
...anton.		

This punched ticket was used for travel on a first-class car in the 1860s. It lists 107 stops along the line between Baltimore, Maryland, and Wheeling, Virginia. The ticket could be torn to allow both the conductor and the passenger to retain a copy. The bottom section listed the stations and their assigned numbers; the shorter portion of the ticket listed just the numbers of the stations.

33

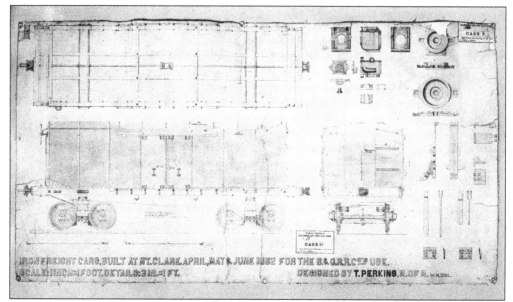

The B&O used iron boxcars to carry freight along its route. These cars were manufactured at the B&O's Mount Clare Shops using the specifications laid out in the plans above. The cars were designed by Thatcher Perkins, who served as the railroad's master of machinery during the Civil War. Perkins is sometimes remembered more for the 10-wheel locomotives he designed; however, the iron boxcar proved crucial to rail operations and served as the basis for the Civil War boxcars created to protect soldiers. The photograph below shows a surviving iron boxcar in Baltimore. The collection at the B&O Railroad Museum includes two such cars, one of which was damaged in the roof collapse of 2003.

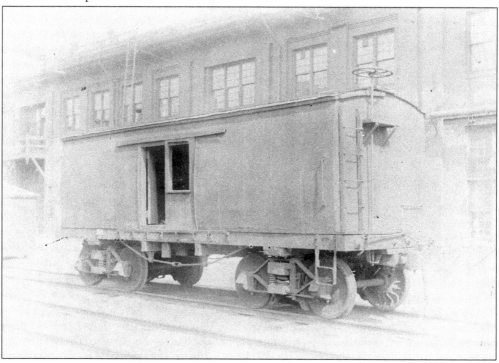

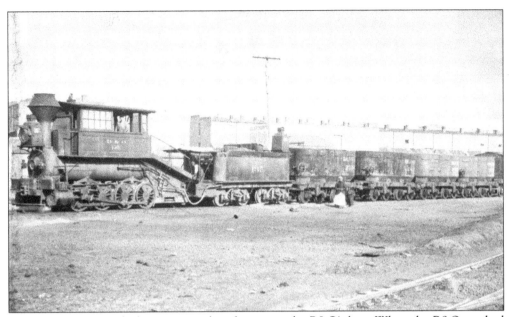

This 1850s photograph shows a typical coal train on the B&O's line. When the B&O reached Cumberland and points west, coal became black gold to the railroad and a significant source of revenue. CSX continues to haul coal on the old B&O line to the port of Baltimore, where it is shipped abroad for foreign consumption rather than domestic use.

Opened in 1857, Camden Station served as the B&O's premier Baltimore passenger station and headquarters until the mid-1880s. Designed by Baltimore firm Niernsee & Nielson, it was built in the Italianate architectural style. The railroad purchased the site in 1852 and cleared existing properties and began construction in 1856. It housed offices, passenger accommodations, and freight facilities and saw many changes over its history.

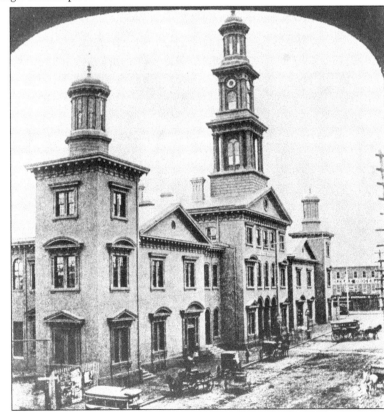

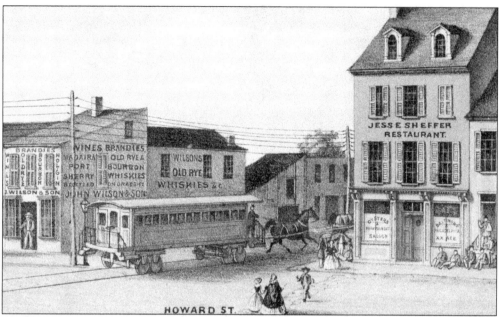

The above image is a detail of a Civil War–era print showing Baltimore City's Pratt Street and a B&O passenger coach being pulled by a horse. Baltimore City ordinances prohibited the use of steam engines in the downtown business district at the time. The law was created because of the fear of fire, scaring horses, and disrupting business in the bustling downtown. This contributed to the Pratt Street Riot in April 1861. As depicted below, Southern sympathizers attacked a Massachusetts militia moving through the city on its way to Washington following the attack on Fort Sumter. Residents blocked the rails, forcing the troops to march to Camden Station. The ensuing chaos led to casualties on both sides—the first deaths of the American Civil War.

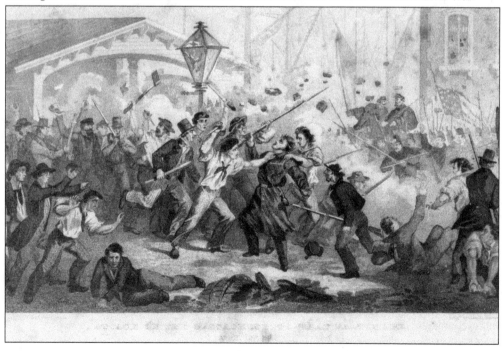

The B&O's Washington branch provided the only rail route into Washington, DC, from the North, and it was critical that the Union maintain control of the tracks. B&O trains carried hundreds of thousands of soldiers and necessary war supplies throughout the conflict. Vital junctions, like Relay House, were guarded throughout the war against possible sabotage and to ensure the line remained open. Here, Union troops pose on the passenger platforms in front of Relay House.

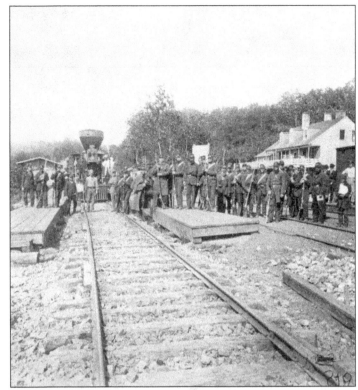

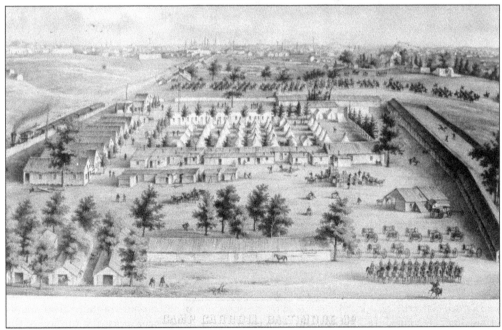

Camp Carroll was located along the B&O's right-of-way, about a mile from the Mount Clare Shops. The camp served as a training ground for newly formed units. Soldiers from the camp also guarded the railroad and were called out on several occasions to deal with disagreements between pro-Union and pro-Confederate shop workers.

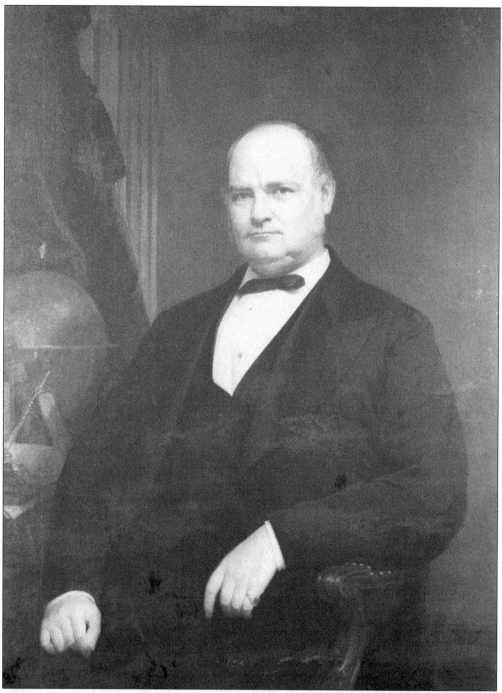

John Work Garrett (1820–1884) was one of the most successful and prominent railroad presidents of his time. He guided the B&O for 26 years, through financial uncertainty, the turmoil of the Civil War, and labor unrest in 1877. Garrett expanded the B&O into one of the most influential railroads in America. Garrett County, Maryland, was named for him in 1872.

Three

THE VICTORIAN B&O
1866–1900

Following the Civil War, the B&O entered a time of grand expectations and growth, but it also faced two periods of economic uncertainty. During this period, the modern B&O begins to emerge, as the line reached areas that would prove vital to its operations into the 20th century. Many of the buildings and stations constructed during this time would last well into the next century.

In Maryland, the Metropolitan branch opened between Point of Rocks and Washington, DC, in 1873, providing a more direct route from the capital to the west. It expanded northward from Cumberland to Pittsburgh, Pennsylvania, and westward to Chicago, Illinois. Baltimore City would see the completion of the Belt Line and Howard Street tunnel as it constructed its own route from Baltimore to Philadelphia. In the 1890s, a small portion of the Belt Line would be electrified, resulting in the first main line electrification of a railroad.

The railroad entered the resort business in the 1870s, opening hotels in Cumberland, Deer Park, Relay, and Oakland. A major station-building campaign occurred in the 1880s and 1890s, resulting in construction of many of the classic stations that still exist, like Sykesville, Oakland, Gaithersburg, and Mount Royal. These stations and depots provided the backdrop for everyday life, serving the rich and famous, Washington politicians, and the average man. From folks traveling to visit friends or family, to companies shipping goods, the railroad station was a hub and hive of constant activity.

The B&O suffered several major financial crises as well. Economic panic and poor working conditions resulted in the strike of 1877. What began on the B&O in Martinsburg, West Virginia, spread like wildfire to Baltimore and across the nation. A second crisis, in the 1890s, forced the B&O into receivership and left it under the control of its archrival, the Pennsylvania Railroad.

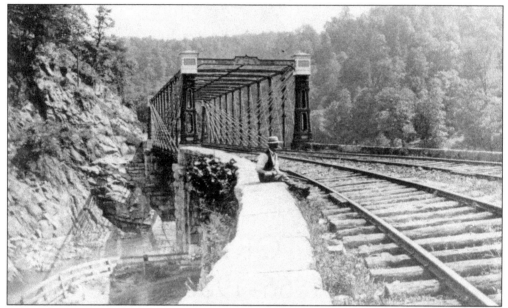

When the Patterson Viaduct was washed away in 1866, it was replaced by an iron truss, which was destroyed in the great flood of 1868. This would be replaced by a Bollman truss bridge. It stood until the track realignment and creation of the Ilchester Tunnel in 1908.

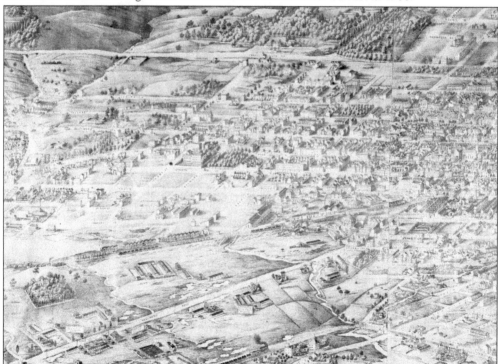

The B&O's Mount Clare Shops are seen in this lithograph, "Edward Sachse's Bird's Eye View of City of Baltimore 1869." It is easy to see, in the center of the image, the industrial center the shops had become, with multiple roundhouses and buildings. The angled buildings in the lower left are engine houses on the B&O's right-of-way.

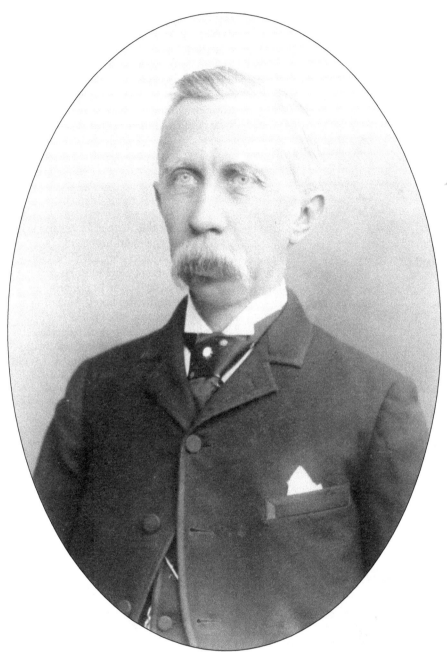

Ephraim Francis Baldwin (1837–1916) is best remembered in railroad circles for his designs of buildings and stations for the B&O. Baldwin began his career as a draftsman with the firm of Niernsee & Nielson, which designed Camden Station. He worked there until 1867. After a short partnership with Bruce Price, he entered private practice and was named the B&O's head architect in 1872. In 1883, he partnered with Josias Pennington, who had been a draftsman at Baldwin & Price. The firm Baldwin & Pennington worked for the B&O for over 25 years, designing simple freight houses; large and small passenger stations, including Mount Royal Station, Sykesville, and Oakland's depot; and the 1884 passenger car roundhouse at Mount Clare. He is also known for his nonrailroad work, including churches, schools, public buildings, and warehouses.

This west-facing photograph of the Sykesville station was taken by the railroad during the Interstate Commerce Commission's efforts to value the railroad in 1920. The depot opened in 1884. It was described as 90 feet long and 28 feet wide, with a telegraph and ticket office between two waiting rooms. The upstairs contained offices. Today, the building is operated as a restaurant.

The B&O built the Viaduct Hotel and station in 1873 where the main line headed south along the Washington branch. The Gothic structure, designed by Ephraim Francis Baldwin, replaced the Relay House as the primary station, restaurant, and hotel. As dining and sleeping cars became more popular on the B&O's line, the hotel's business decreased. By the early 1900s, the building was being used for other purposes, including as a shelter for the B&O Relief Department. It was closed in 1929 and demolished in 1950.

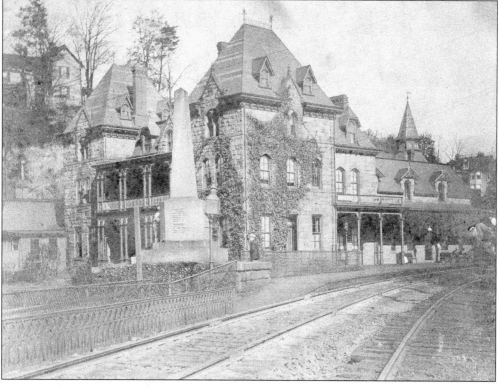

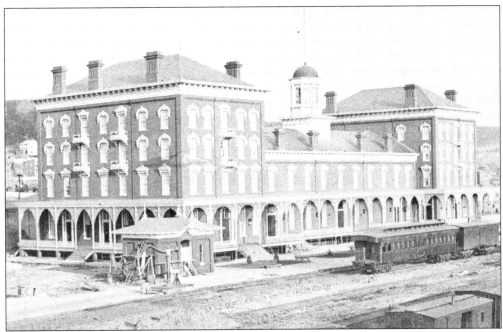

Cumberland's Queen City Hotel and station opened for business in the fall of 1872. It was one of five combination hotels and stations operated by the B&O. Designed by Thomas Heskett in the Italianate style, the hotel contained 174 rooms and was a summer resort on the B&O's route to Pittsburgh. Covered platforms were added in 1912. The hotel closed to the public in 1964 and suffered a fire in 1969. The structure was torn down in 1972.

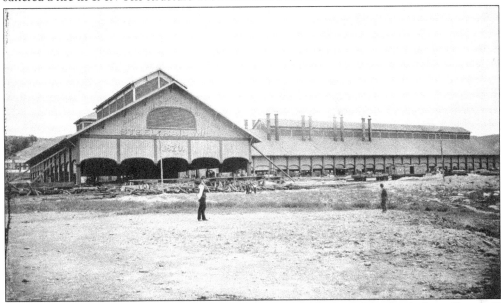

Located at the end of Elm Street and Locust Alley in Cumberland, Maryland, this rolling mill initially manufactured rail for the B&O's track. Its design allowed the railroad maximum flexibility in the use of the facility and the arrangement of machinery necessary for the manufacturing process. Access to coal and a reliable labor force provided the B&O with an ideal location for the mill. It was demolished in 1981.

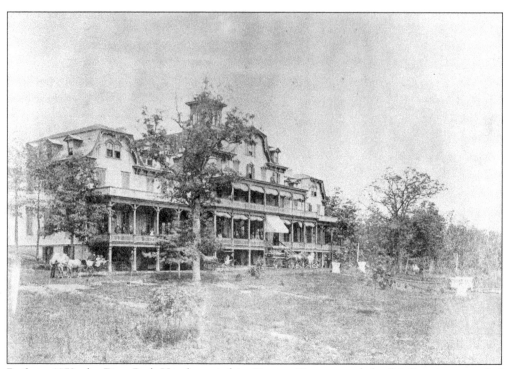

Built in 1873, the Deer Park Hotel opened in Garrett County, and the B&O trains provided service to this western Maryland oasis. One of several luxury hotels built by the B&O, it became a popular destination and retreat for politicians and presidents. Grover Cleveland and his new bride, Frances, spent their honeymoon at the hotel in 1886. The main hotel building is shown above. The hotel operations at Deer Park expanded in the 1880s with the addition of an eastern annex (below), a western annex, and several cottages. The hotel closed in 1929 during the Great Depression and was severely damaged by fire in the 1940s.

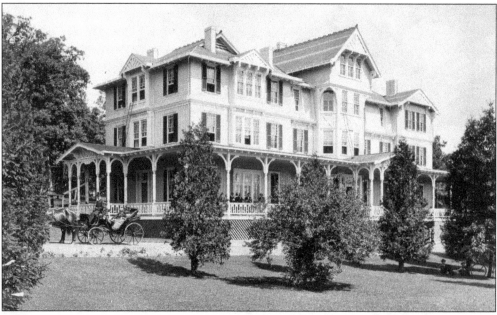

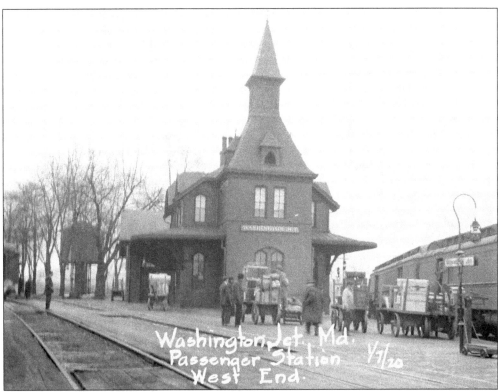

Washington Jct. Md.
Passenger Station 1/1/20
West End.

Point of Rocks was critical to the B&O's plans to head west. Its proximity to the C&O Canal led to severe legal wrangling that held up construction until a compromise was reached in the 1830s. The station (above) was completed in 1875. Situated at the juncture of the B&O's main line and the newly opened Metropolitan branch, it provided access to Washington, DC, without the necessity of going to Relay, Maryland, via the Washington branch. The station featured waiting rooms, a ticket booth, and a tower. It was renamed Washington Junction in 1876, as it was known when the photograph was taken in 1920. In 1923, the name reverted to Point of Rocks. The photograph below is an early view of the tunnel at Point of Rocks. Created shortly after the Civil War, it has been modified and is still in use today.

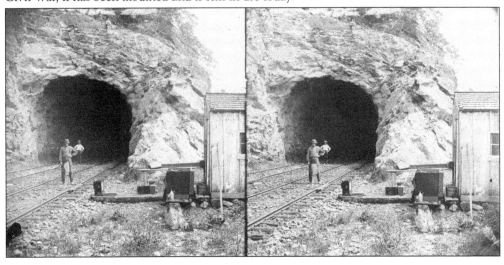

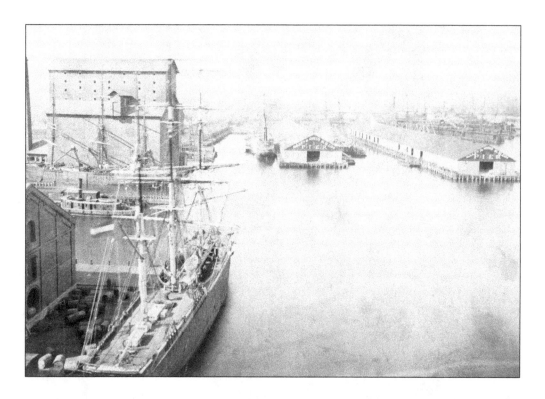

Named after the locust trees that were prevalent in the area, Locust Point became a major rail and shipping hub beginning in the 1840s, when the B&O built track and piers to accommodate larger ships than could be handled in Fells Point. The above photograph, taken about 1875, shows a grain elevator and piers Nos. 6, 7, 8, and 9. Piers No. 8 and No. 9 were constructed in 1867 and served as the point of entry for thousands of immigrants from Central and Eastern Europe. They traveled to Baltimore via the North German Lloyds Company, which partnered with the B&O. The arrangement helped make Baltimore one of the largest immigration reception points in the United States. The photograph below shows the large grain elevators. The hoppers are loaded with coal, another major natural resource shipped out of the facility.

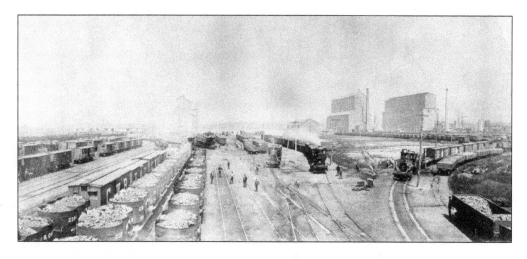

WESTWARD.

STATIONS.	Dis.	96 Frt.	98 Frt.	60† Pass.	62† Pass.	30 Frt.	64 Pass.	14 Pass.	10† Pass.	66† Pass.	68 Pass.	70 Pass.	72† Pass.	16 Pass.
	A.M.	A.M.	A.M.	A.M.			A.M.	A.M.	A.M.	A.M.	A.M.	A.M.	A.M.	P.M.	P.M.
Camden Station..Leave	4 45	5 15			6 50	7 25	7 30	8 45	9 20	10 30	12 30	1 30
Carroll				4 52	5 23				6 57	7 32	7 37	8 52	9 27	10 37	12 37	1 37
Camden June	4	1 20	4 00	4 54	5 24			5 25	6 59	7 34	7 39	8 54	9 29	10 39	12 39	1 41
Relay Station....Arrive				5 05	5 13											
"Leave	9	1 36	4 16	5 05	5 32			5 43	7 09	7 42	7 47	9 05	9 37	10 47	12 49	1 53
Elk Ridge	9½	1 41	4 19	5 07	5 34				7 11		7 49	9 07	9 38	10 48	12 51
Hanover	11½	1 53	4 33	5 13	5 37				7 16		7 53	9 12	9 41	10 51	12 56	
Dorsey's	14¼	2 05	4 47	5 18	5 41				7 22		7 57	9 18	9 45	10 55	1 02	
Jessup's	16¼	2 15	4 59	5 24	5 44				7 27		8 00	9 24	9 48	10 58	1 07	
Annapolis Junc..Arrive				5 13					7 32		8 04	9 30	9 53	11 01	1 12	
" ..Leave	18¼	2 27	5 53p	5 30p	5 47p				7 35		8 06	9 33	9 56	11 03	1 15	
Savage	20¼	2 35	5 59	5 33	5 50				7 35		8 06	9 33	9 56	11 03	1 15	
Laurel	22¼	2 46	6 10	5 37	5 53				7 40		8 09	9 37	9 59	11 05	1 19	
Contee's	24¼	2 57	6 21	5 41	5 57				7 46		8 13	9 41	10 02	11 08	1 24	
Beltsville	28	3 13	6 38	5 48	6 02				7 54		8 16	9 48	10 06	11 12	1 31	
Paint Branch	31½	3 31	6 56	5 55	6 08				8 03		8 20	9 55	10 11	11 17	1 39	
Alexandria June	34½	3 45	7 08	6 00	6 12				8 08		8 23	10 00	10 14	11 20	1 44	
Metropolitan June	39	4 13	7 30	6 10	6 20				8 20		8 30	10 10	10 20	11 26	1 55	
Washington.....Arrive	40	4 20	7 55	6 15	6 25				8 25		8 35	10 15	10 25	11 30	2 00	**

This January 1876 timetable lists the arrival and departure times for westbound passenger and freight trains on the Washington branch. The stations along the line, largely rural at this time, would expand with the continued growth of the B&O to become thriving commuter and freight hubs. As with modern lines, there were express trains and those that stopped at every station, resulting in the different times on the timetable. Some passenger trains could make the trip from Baltimore to Washington in one hour and 30 minutes or one hour and five minutes.

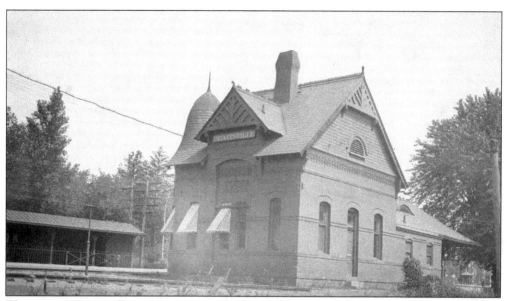

The ornate Hyattsville station was one of the largest stations on the Washington branch between Washington, DC, and Baltimore when it opened in 1884. The structure was designed by Ephraim Baldwin in the Queen Anne style. When completed, it proved to be the center of a growing community nestled along two major routes of travel, the B&O and the Washington & Baltimore Turnpike.

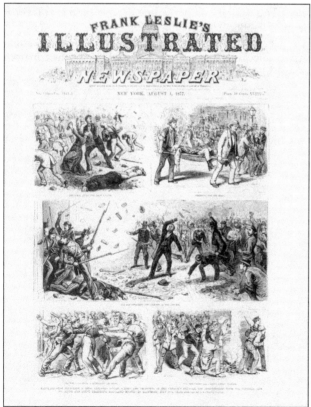

The cover of the August 4, 1877, edition of *Frank Leslie's Illustrated* depicts scenes along the B&O during the strike of 1877. The violence was pervasive and disruptive to B&O operations. Eventually, Maryland's governor would call out the 5th and 6th Regiments of the National Guard. They were attacked on their way to Camden Station. The survivors would be used to control the situation and protect the railroad's property.

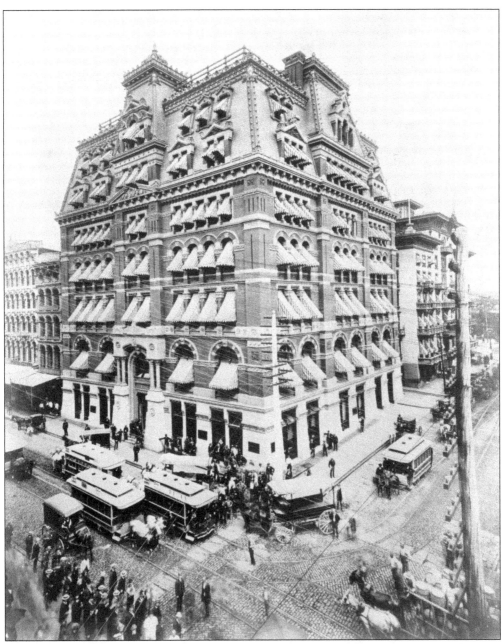

Located on the corner of Baltimore and Calvert Streets, the B&O's Central Office building was constructed in 1882 under the direction of John Garrett. When it was completed, the president's office moved to the site, as did other functions, including record keeping. The ornate structure was reported to be fireproof; however, the fire of 1904 proved otherwise.

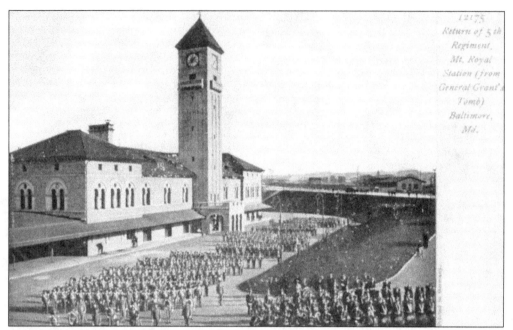

Mount Royal Station opened for service in September 1896 as part of infrastructure to support and connect Baltimore operations with Philadelphia. Designed by Baldwin, its exterior featured granite, limestone, and terra-cotta tiles in a mix of Renaissance and Gothic styling and a working clock tower. This postcard depicts the Maryland National Guard's 5th Regiment returning from the dedication of Pres. Ulysses S. Grant's tomb in April 1897.

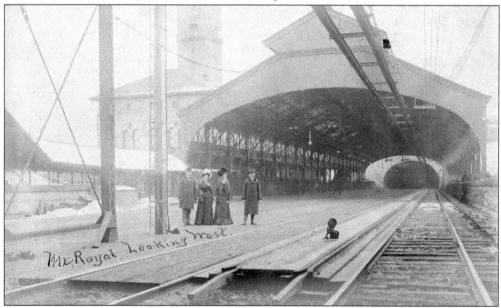

This south-facing photograph looks into the train shed and the mouth of the Howard Street Tunnel at Mount Royal Station in the late 1890s. Construction of the tunnel began in 1890 and was completed in 1895. The 1.4-mile tunnel went directly under Howard Street. Electrification of the line was critical to its success and was accomplished in June 1895, marking the first main line electrification in the nation.

This early postcard shows the B&O's Boyds, Maryland, station in 1892. The station was named after Col. James Alexander Boyds, a B&O construction engineer who worked on this section of the line. The station, built in 1887, was eventually removed in 1927 to make way for double tracking on the Metropolitan branch. In front of the station's freight storage area is an early railroad signal accessed by a ladder.

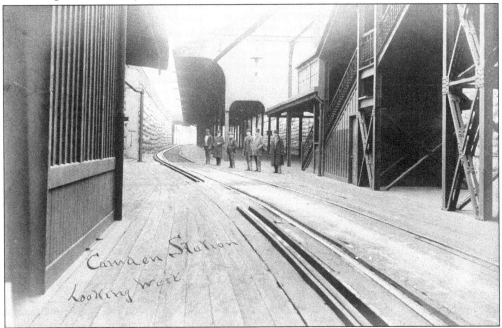

This photograph looks west at the passenger platform built at Camden Station for trains using the Howard Street Tunnel. The platforms allowed for direct access to the tunnel, as the entrance was below street level. Prior to construction of the platform, trains had to back out of the station and then enter the track leading to the tunnel. The platform allowed trains to board passengers on the track leading directly into the tunnel.

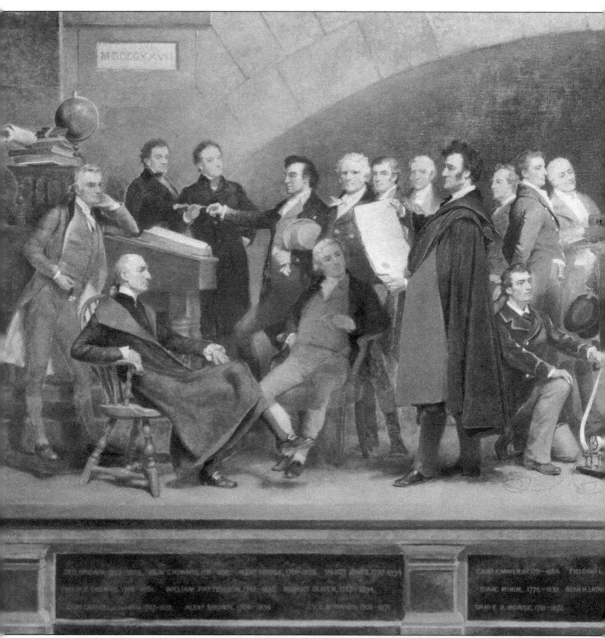

B&O president John W. Garrett commissioned Francis Blackwell Mayer to paint an allegorical image of the most significant men involved with the B&O from 1827 to 1880. Mayer's masterpiece was known as "The Founders of the Baltimore and Ohio Railroad." Seated on the far left is Charles Carroll of Carrollton, guest of honor at the laying of the first stone, B&O director, and American patriot. A kneeling Samuel Morse, located in the center of the image, holds the tape

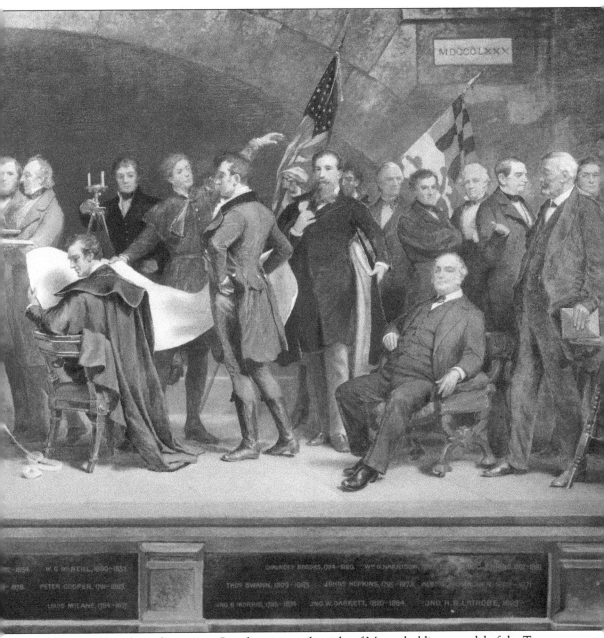

W.G. McNEILL, 1800-1853 CHAUNCEY BROOKS, 1794-1880 W.G HARRISON

PETER COOPER, 1791-1883 THOS SWANN, 1809-1883 JOHNS HOPKINS, 1795-1873

LOUIS McLANE, 1784-1857 JNO B MORRIS, 1785-1874 JNO W GARRETT, 1820-1884 JNO H B LATROBE, 1803-

from his first telegraph message. Standing just to the right of Morse, holding a model of the Tom Thumb steam engine, is its inventor, Peter Cooper. Seated on the far right is John Garrett, the B&O's guiding force during and after the Civil War. The original painting hangs in the CSX corporate headquarters in Jacksonville, Florida. A reproduction is on display at the B&O Railroad Museum in Baltimore.

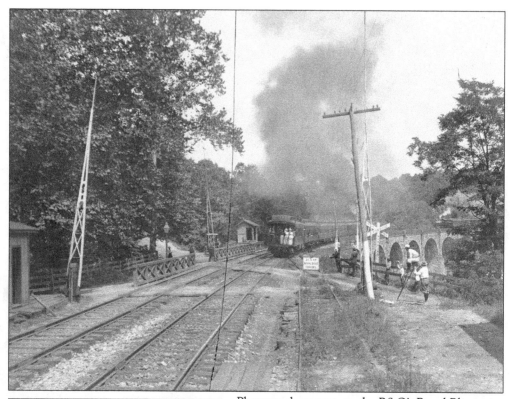

Photographers capture the B&O's Royal Blue as it steams north over the Thomas Viaduct in the late 1890s. The Royal Blue was a luxurious passenger train operating between Washington, DC, and New York. Operated in conjunction with the Reading Railroad and the Central Railroad of New Jersey, the trains were fast, comfortable, and the premier passenger train of the day for the B&O.

Situated on the Washington branch, the Laurel station was originally called Laurel Factory. The current station dates to the B&O's upgrades and building efforts of the 1880s. The depot opened in 1884 and was designed by Ephraim Baldwin. The building was gutted by fire in 1992, but it has since been restored, and it continues to serve the community as a MARC station.

Four

A New Century and Prosperity
1900–1927

The first quarter of the 20th century was a time of recovery and prosperity for the B&O. Nationally, its line continued to grow. It formally added stops to Cincinnati and St. Louis and, for a brief period, had direct access to New York. Overall, the system benefited from increased freight and passenger traffic. In part, this was due to increased traffic during World War I, but it also benefited from postwar optimism.

Locally, the century began in devastating fashion, as the B&O's Baltimore headquarters was destroyed in the great fire of 1904. The railroad would rebuild a new General Office building and expand its Baltimore port facilities at Locust Point and Curtis Bay. The B&O even introduced the employee magazine, with operations centered in Baltimore. Stations along the Washington and Metropolitan branches were still rural by modern standards, and many of the surrounding localities would not be recognizable today.

The railroad upgraded its infrastructure, passenger service, and locomotive fleet. It is during this time that two of the B&O's premier passenger trains trace their beginnings. The Capitol Limited operated through Maryland from Washington, DC, to Chicago, and the National Limited operated from New York to St. Louis. Both were all-Pullman lines and provided excellent accommodations. Heavier, faster, and more powerful locomotives entered service, like the Mikado, and the yards along the line, like Brunswick, Cumberland, and Mount Clare, were heavily active supporting operations.

In 1910, Daniel Willard took over the helm of the B&O. He proved to be as strong a leader, and as legendary a figure, as John Garrett, guiding the railroad until his retirement in 1941. From 1910 to 1927, he oversaw a golden age of prosperity and the heyday of steam power on the B&O. This period culminated with the celebration of the 100th anniversary of the B&O and of railroading in America.

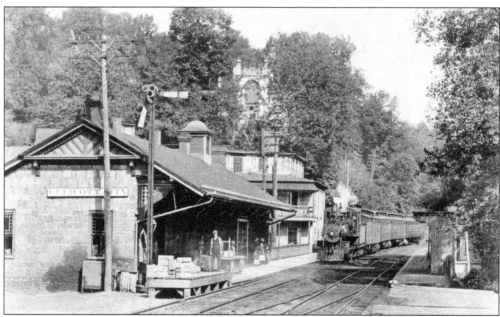

These photographs of the Ellicott City station show the east and west approaches. Above, an eastbound passenger train approaches the station in the early 1900s. This widely recognized image shows changes to the station. The east end of the building once housed a car shop, and locomotives were stored inside. The doors were removed with the changes over time, and the once important turntable is no longer visible. Below, a westbound train approaches the platform with waiting passengers. The building on the right in the foreground was originally known as the Patapsco Hotel. In the early days of railroading, passengers purchased their tickets and boarded the train from the hotel, since the depot was used for freight until it was modified to accommodate both passenger and freight service in 1857.

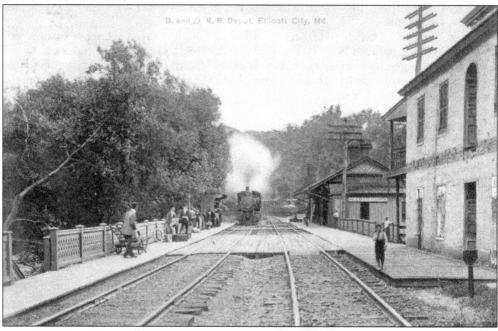

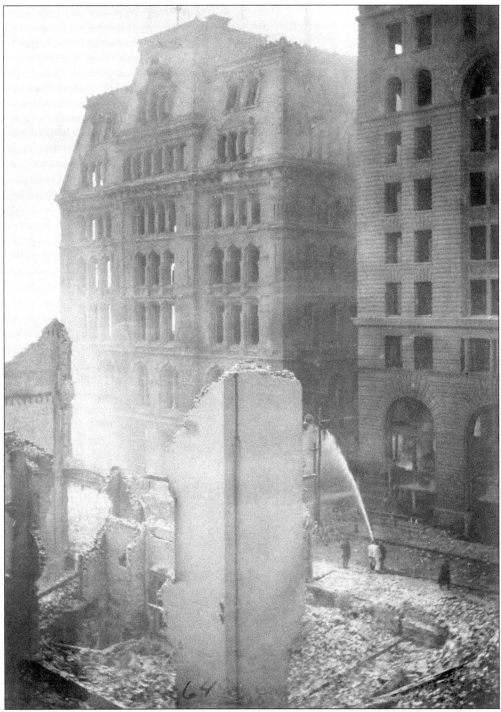

On February 7, 1904, a devastating fire destroyed over 1,000 buildings constituting the majority of Baltimore's downtown financial district. The fire gutted the B&O's central headquarters. The most important records were able to be saved before the fire reached the building, but a considerable amount of information about the B&O's operations and history were lost in the fire.

In September 1906, Baltimore celebrated its recovery from the 1904 fire, and the B&O participated. The festivities included three parades on consecutive days. The first included a military procession. The second was an industrial procession that included 6,000 B&O employees. The third parade consisted of a large contingent of firefighters from localities that helped combat the blaze. This postcard shows B&O workers marching in formation.

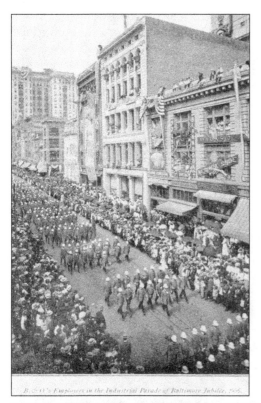

B. & O.'s Employees in the Industrial Parade of Baltimore Jubilee, 1906.

A celebration was held in front of the B&O's new General Office building, erected two blocks west of the headquarters destroyed in the 1904 fire. This is more than likely the opening ceremony for the office building, which cost $2.4 million and was constructed in the shape of an "H" for maximum light and ventilation. It contained 250,000 square feet, 5.5 acres of floor space for offices, ornate lobbies, and 1,784 windows.

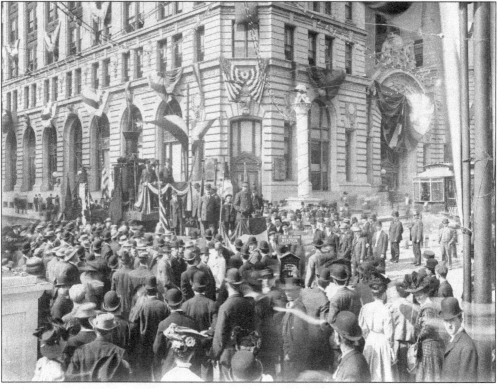

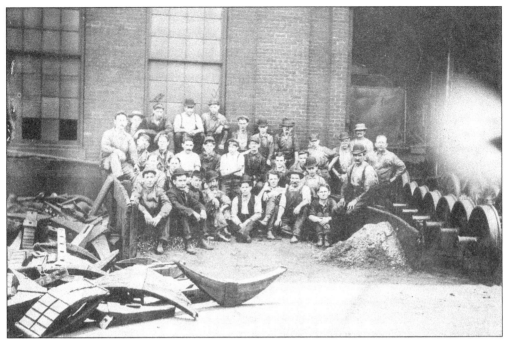

The B&O's shop staff gathers outside a roundhouse at Riverside in the early 1900s. An "X" marks the location of Joseph Irwin Say. Born in 1887, Say was in his teens when this photograph was taken. He served as an apprentice. The workers are sitting between elliptical and leaf springs, used as suspension rigging on railroad wheel sets, seen at right.

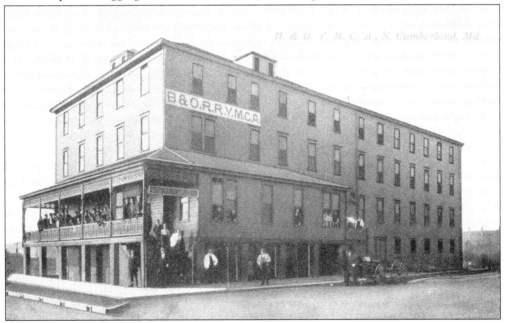

Purchased by the B&O in 1905, this building was located on Virginia Avenue in Cumberland and served as the B&O YMCA. Railroaders and train crews in particular used its services as a clean and safe place to stay. In addition to rooms and baths, it contained an auditorium for shows and religious services. It closed in 1967.

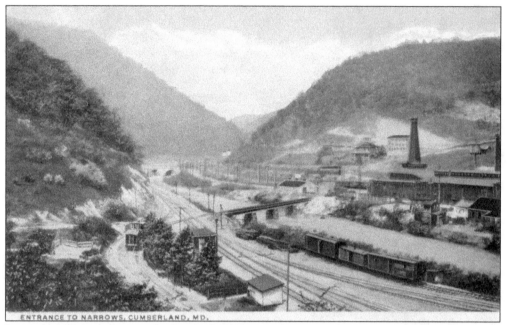

ENTRANCE TO NARROWS, CUMBERLAND, MD.

Located in Allegany County, the Cumberland Narrows lie just northwest of Cumberland. Originally an Indian path, it was used by General Braddock on his ill-fated attempt to remove the French from the Ohio River Valley in the 1750s. It also served as the route of the National Road, and eventually, it would see the B&O's line west.

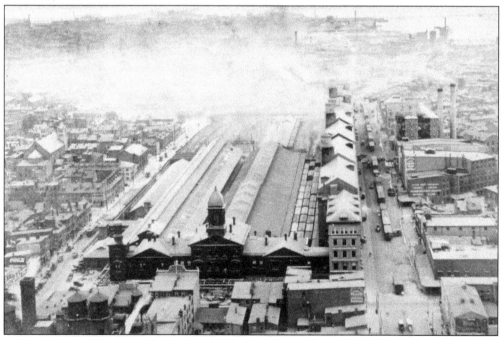

This 1912 photograph of Camden Station emphasizes the sheer size of the site and associated operations. Located behind the main building are the covered train platforms. The freight offices and warehouse extend down the western side of the building. In the upper right is Bailey's Roundhouse, located on the corner of Ostend, Eutaw, and Stockholm Streets.

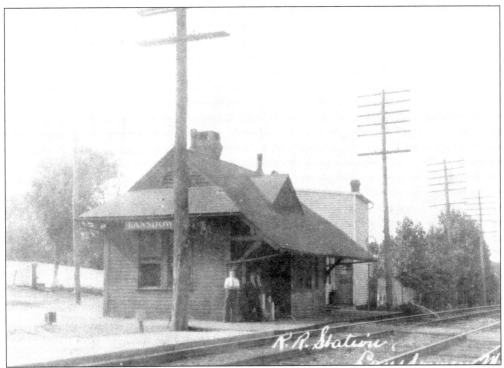

By all accounts, Lansdowne was a B&O town. The depot was listed on early maps as Coursey Station because it sat on the property of William Coursey. This postcard image shows the station as it appeared in 1912. It served as a commuter station, and many of the local residents worked for the railroad.

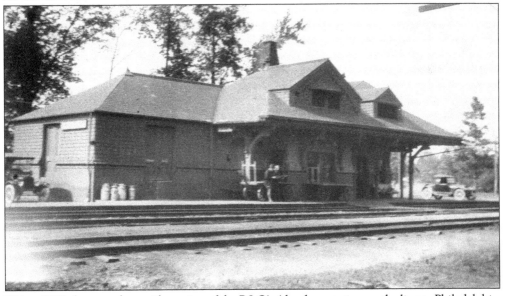

This c. 1915 photograph provides a view of the B&O's Aberdeen station on the line to Philadelphia. Built in 1885, the station still exists but is in poor condition. It was condemned and slated for destruction, but the Historical Society of Harford County, Inc., is leading efforts to save and restore it.

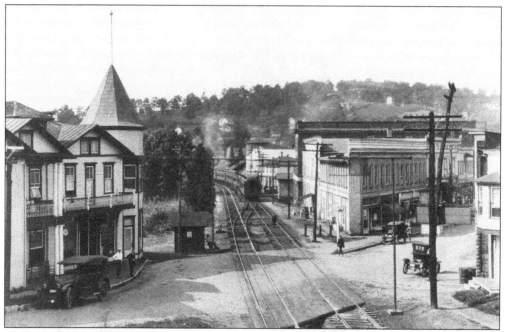

A passenger train pulls past the Oakland station around 1915. This wonderful photograph shows the relationship of the station and its activities to a bustling town. The grade crossing lacks crossing gates, but it does have a flagman's booth, the small shack next to the tracks.

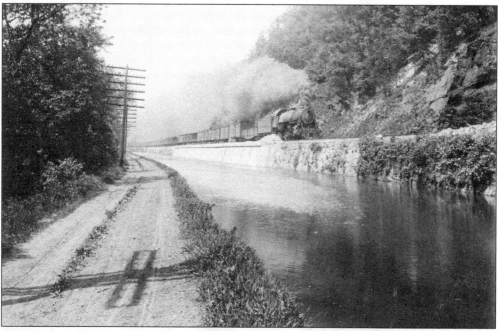

A B&O freight train travels along the C&O Canal in western Maryland. The canal and the railroad were bitter rivals when both began in the late 1820s. Competing for traffic, resources, funding, and geography, both felt they were the future of transportation in the state and crucial to the success of the local economy. The railroad and the canal competed with each other for many years, until the canal was purchased by the B&O.

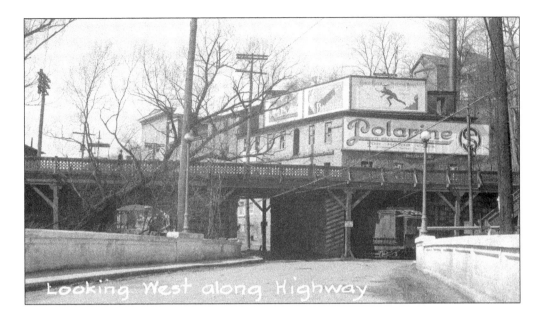

Looking West along Highway

These 1920s photographs of the B&O's Oliver Viaduct show three avenues of transportation meeting in Ellicott City. The above photograph looks west toward Ellicott City from the Baltimore County side of the Patapsco River. The viaduct, completed in 1830, had three stone arches, one over the Tiber River and two over Main Street. The arches over Main Street were replaced with a steel span in the early 1900s. To the right in the above photograph is the bridge for trolley line No. 9, which shuttled commuters between Ellicott City and Baltimore from the late 1890s until 1955. It was a more direct route than the B&O's main line. The photograph below looks east toward the river. The bar on the right sat on the corner of Maryland Avenue and Main Street. Here, it blocks the view of the 1831 depot.

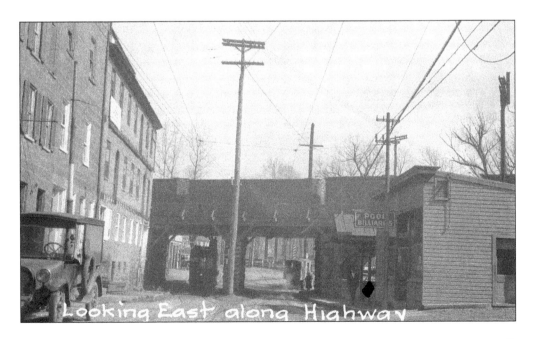

Looking East along Highway

The B&O's Gaithersburg station (above) and freight house (left) along the Metropolitan branch are seen in these 1920s photographs. Another Baldwin-designed building, the station was a bustling commuter location and served the local milling industry. The railroad operated local trains between Washington and this stop, and there were as many as 30 trains stopping or continuing through here in the early 1900s. Today, the station still stands and is used as a MARC stop for commuters and the site of a small coffee shop, Java Junction. The freight house contains the Gaithersburg Community Museum, which features rotating and permanent exhibits on the railroad and development of the town. In addition to a steam engine and caboose, the museum recently acquired a self-propelled B&O passenger BUDD car from the B&O Railroad Museum.

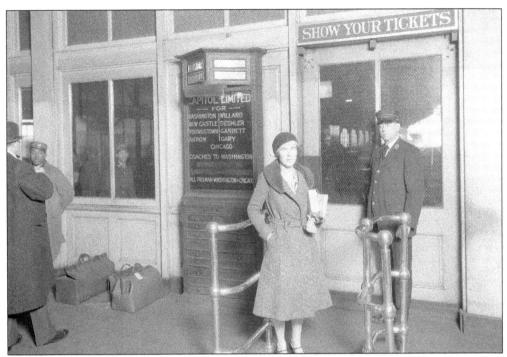

A passenger waits to board at Camden Station in the 1920s. It is probable that she will be riding the Capital Limited, an all-Pullman train traveling between Washington, DC, and Chicago. Sleeper cars would stop at Camden and then join the Capital Limited in Washington. The young African American man at left is a red-cap baggage handler waiting to assist passengers.

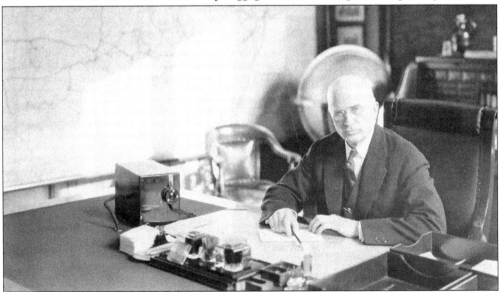

Daniel Willard (1861–1942) was one of America's key railroad figures in the 20th century, serving as B&O president for 31 years. His progressive management style and ability to relate with workers allowed him to successfully guide the B&O during its golden age and through the Great Depression. A close advisor to presidents and respected by labor unions, Willard was affectionately known as "Uncle Dan."

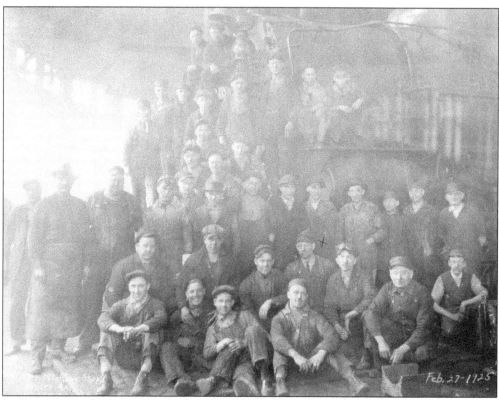

In the photograph above, employees of the B&O's Riverside machine shop gather in front of and on a locomotive in the roundhouse on February 27, 1925. The roundhouse was one of two located at the Riverside Shops, built in 1907 to handle locomotive servicing. The "X" marks the location of Joseph Irwin Say (third row, fifth from right). The photograph below shows the shops in the 1920s, about the time the workers posed for their photograph. One of the roundhouses is located to the left. While the yard still exists, the roundhouses have been removed. Riverside was the site of CSX and MARC operations for many years. CSX ended its presence in 2013. MARC outsourced passenger operations the same year, selling the facility to Bombardier.

One of the most noted female civil engineers of her time, Olive Dennis (1885–1957) broke many barriers in her distinguished career. The second woman to graduate from Cornell University's engineering program, she began her career in 1920 and quickly impressed management. Dennis eventually answered directly to Pres. Daniel Willard. Among her recommendations and design changes to passenger cars were stain-resistant seats, reclining seats, dimming lights, and overall air-conditioning of coaches.

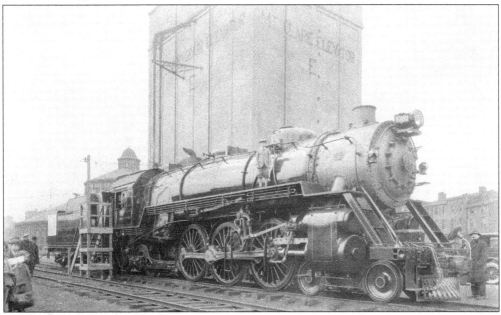

The B&O's new locomotive, *President Washington* (No. 5300), is on display in front of the Mount Clare grain elevator on March 27, 1927. The engine was the first of 20 class P-7 Pacific-type locomotives built for the B&O by Baldwin Locomotive Works in 1927. These locomotives were named after the first 21 US presidents. A single *President Adams* represented both John and John Quincy Adams.

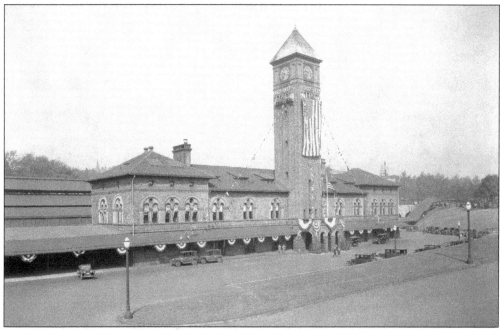

Mount Royal Station is seen above in 1927. In the photograph below, the vestibule of the observation car is packed with passengers on the B&O's Capitol Limited as it prepares to head south through the Howard Street Tunnel. The Capitol Limited was the B&O's premier train when it began service in 1923 between New York City and Chicago. While the line could not compete with the speedier passenger trains of the Pennsylvania Railroad and the New York Central, it was known for the quality of its service. The luxurious all-Pullman sleeper-car train featured amenities such as a barber, manicurists, maids, and secretaries. Passengers enjoyed fine cuisine on diners such as the *Martha Washington*. Today, the Capitol Limited is one of Amtrak's premier trains, operating between Washington, DC, and Chicago.

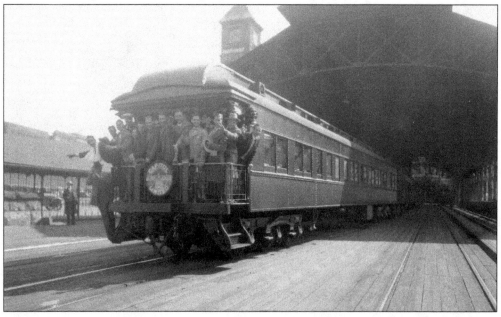

Five

THE FAIR OF THE
IRON HORSE
1927

Conceived to celebrate the 100th anniversary of the B&O Railroad, the Centenary Exhibition and Pageant of the Baltimore & Ohio Railroad would go down as one of the most successful commemorative events in the history of railroading. Commonly referred to as the Fair of the Iron Horse, it told the story of inland transportation in America. It opened on September 24, 1927, and was supposed to end on October 8. Due to its popularity, however, it was extended to October 15. Total attendance for the 23-day event was 1,225,000.

The railroad selected a 1,000-acre site in Halethorpe, Maryland. Situated on the B&O's main line outside Baltimore, it was easily accessible by rail and road. The B&O constructed several buildings on the site. The largest, the Hall of Transportation, featured exhibits on the development of rail technology. On the eastern side of the hall was the Allied Services Building, tracing the development of industry related to the railroad, such as telegraphy, the telephone, and express service. On the western side was the Traffic Building, containing exhibits on Locust Point, Curtis Bay, and passenger and freight traffic development. One of the major tasks for the railroad included the restoration of the historic locomotives housed at Bailey's Roundhouse in Baltimore. This was overseen by George Emerson, chief of motive power, and Thomas Stewart, superintendent at the Mount Clare Shops.

The fair's most memorable event was the pageant that took place each afternoon. It featured a parade of people, wagons, and trains, showing the development of land transportation in America. The pageant included over 500 "actors," many of who were B&O employees. It took place on a specially constructed dirt track with a rail track loop over a mile long. Other railroads sent equipment to participate in the fair, including the New York Central's *Dewitt Clinton* and the Great Western Railway of England's *King George V*. The fair marked the end of the golden age of steam railroading in America. The ensuing Great Depression and the rise of diesel technology forever changed the industry.

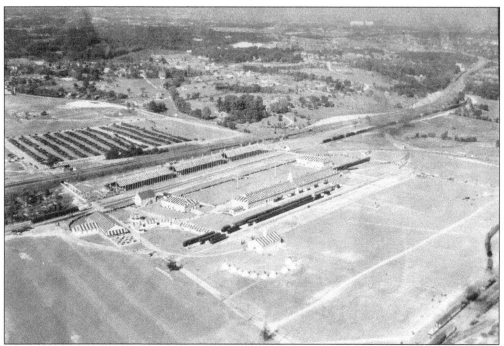

This aerial photograph shows the scope and size of the Fair of the Iron Horse site in Halethorpe, Maryland, in the fall of 1927. Celebrating the 100th anniversary of the B&O Railroad, the fair lasted 23 days and drew over 1,225,000 people. Shown here is a typical day, as visitors arrive and the steam engines assemble on a track (upper right) waiting for the pageant to begin.

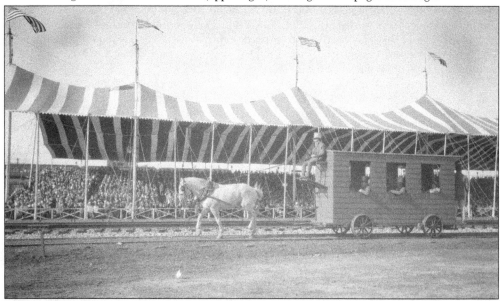

The fair featured a pageant that highlighted the history of land transportation. The parade included Indians, wagons, stagecoaches, floats depicting the history of the B&O, and steam engines from the beginning of railroading to the most modern locomotives in operation in 1927. One of the first railcars featured was the horse-drawn pioneer. The reproduction shown here, dating to 1893, was typical of the cars used to haul the B&O's first passengers.

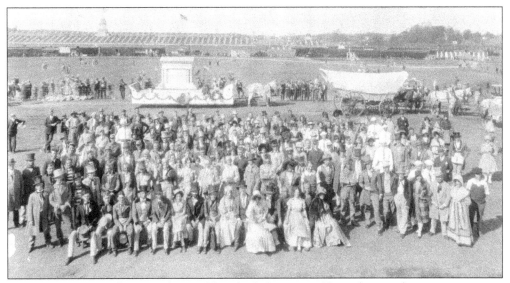

The pageant required a cast of several hundred characters. Here, the parade participants pose in the staging area behind the Hall of Transportation. B&O employees served as actors in important scenes in the creation of the railroad. They walked, road on wagons and horses, and sat on colorful floats representing significant innovations and moments in the development of land transportation in America.

Pageant director Adele Gutman Nathan (1889–1986) adjusts the hair and makeup of one of the participants. The success of the fair led to her subsequent work on the 100th anniversary of International Harvester (1929) and at the 1933 and 1939 world's fairs. Nathan had a lifelong interest in theater, and she found success in Baltimore and New York. She created and directed theater groups, produced plays, wrote for newspapers and magazines, and authored children's books.

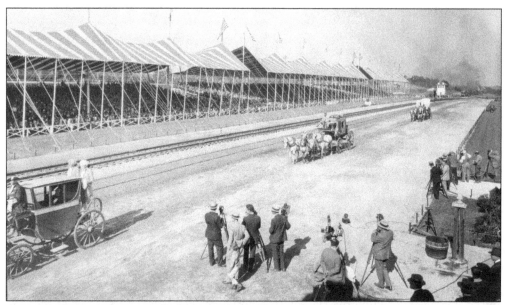

As newsreel movie cameras roll, the procession of horse-drawn stagecoaches and wagons moves past the grandstand. Among the vehicles showing the changes in land-based transportation was the carriage at left, described as a gentleman's carriage of 1775. It was followed by a four-horse stagecoach, dating to about 1825, and a Conestoga wagon. The silent film created during the fair still exists and is exceptional in bringing the event to life.

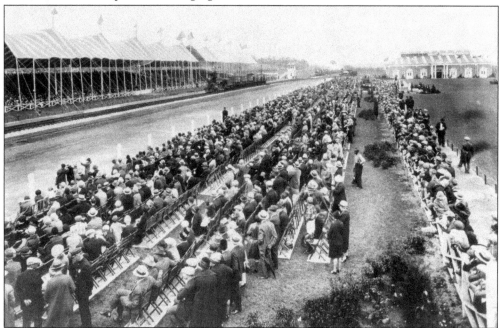

After the procession of early land-based wagons, the pageant transitioned to the history of railroading and, specifically, the B&O. Floats highlighted various themes of the B&O's creation and early history and were interspersed with historic locomotives operating under their own power. Here, the fair's incredible crowds anxiously wait for the next locomotive in the parade to begin its journey.

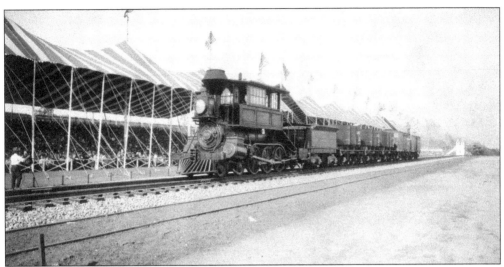

The No. 217 Camel locomotive pulls a historic freight train consisting of three coal hoppers and two boxcars. The Camel was a unique B&O creation by noted inventor and industrialist Ross Winans. As with many of the historic engines used at the fair, they were restored and named in honor of their inventors. This locomotive carried the name "Ross Winans" on its side as well as the number 217.

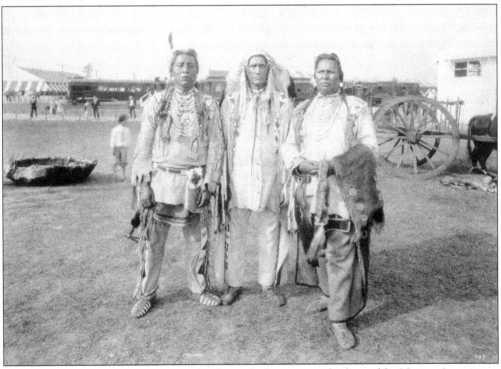

The pageant included a segment on land travel, showing methods used by Native Americans. First to pass the review stand was an assembly described as "A group of American Indians, with heavily laden pack-horses and the primitive travois." They were a very popular component to the pageant. Pictured here are, from left to right, Chief Two Guns White Calf, an unidentified member, and Owen Heavy Breast, whose profile is on the Buffalo nickel.

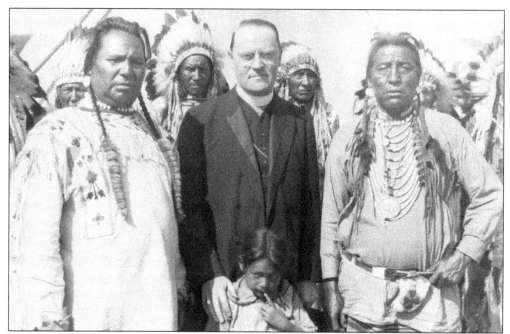

Archbishop Michael J. Curley poses with Owen Heavy Breast (left) and Chief Two Guns White Calf. Curley, the archbishop of Baltimore, was known for his work promoting education and schools. The Native Americans were members of the Blood and Piegan tribes of the Blackfeet Nation. They lived in a camp of teepees on the fairgrounds.

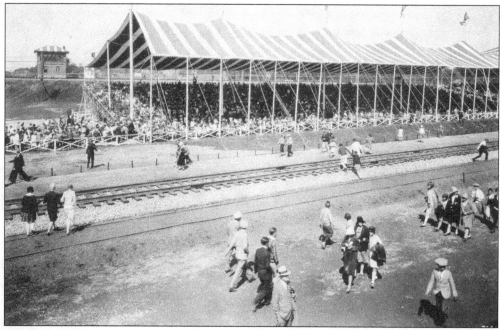

The Halethorpe site consisted of 1,000 acres purchased by the B&O under John Garrett as a potential shop location. Here, visitors file in for the afternoon's pageant presentation. They are coming from the parking lot and trains that brought a majority of the visitors to the site. Halethorpe's HX interlocking tower is located on the hill behind the grandstand.

The B&O spent over $1 million preparing the site, including installation of an oval parade track, pictured here in front of the grandstand. Steam engines are visible in the distance, behind the Hall of Transportation. The fair grandstands are not tented in this image. The tents would be added later during the fair, installed by Loane Brothers, a Baltimore business that began as a sail manufacturer.

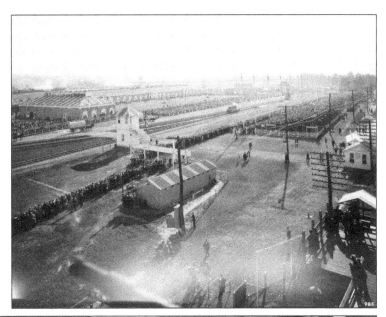

This is the Railroad Time Service exhibit, which noted the contributions that railroading made to standardizing time. It included clocks, pocket watches, clock movements, and "an Old English verge escapement watch, owned and worn by General George Washington." The Standard Clock on the wall to the left is a Seth Thomas No. 3, typical of clocks used by the B&O at the time. This clock is in the museum's collection today.

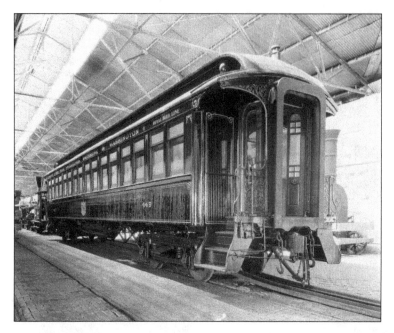

The Hall of Transportation was 500 feet long and 100 feet high and housed exhibits, including the historic No. 445 passenger coach. It was built by the Pullman Company for the Delaware, Lackawanna & Western Railroad around 1890. During the fair, it was rebuilt to resemble a B&O Royal Blue day coach. Several of the historic pieces were modified to resemble equipment that no longer existed.

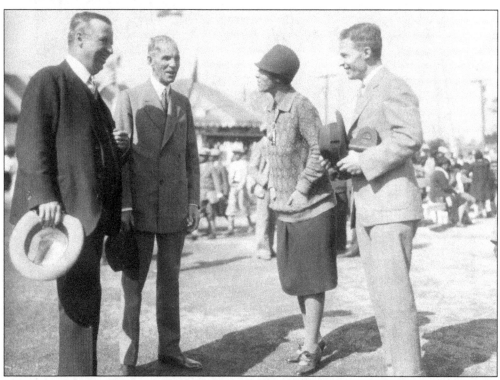

The Fair of the Iron Horse drew many notable figures, including automobile tycoon Henry Ford (second from left). Ford visited the site in September and is pictured here with the director of the fair, Edward Hungerford (left), pageant director Adele Gutman Nathan, and the son of B&O president Daniel Willard, Daniel Willard II (right).

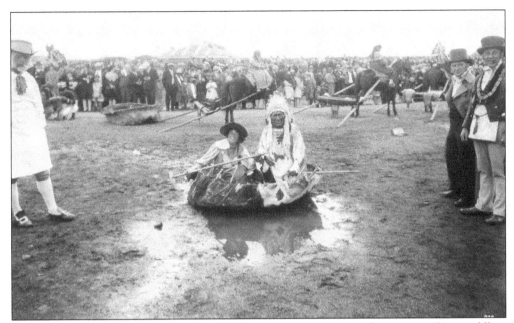

Margaret Talbot Stevens (seated, left) makes the most of the mud after heavy rain. She is paddling with one of the Native Americans. Hired in 1915 as a war replacement clerk, Stevens wrote for the B&O's employee magazine, where she would eventually become the associate editor. Affectionately referred to as "Aunt Mary," her poetry and articles graced the pages of the magazine for years. She helped form the research library and served as its first librarian.

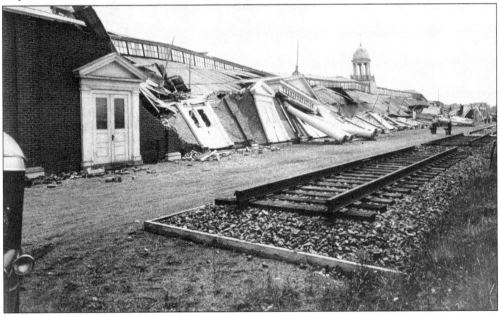

Following the fair, the B&O intended to make the site a museum for its historic collection; however, plans were put on hold due to the Great Depression. The collections were stored on site and were occasionally opened for private tours for VIPs. On August 13, 1935, a severe storm rolled through Halethrope, bringing intense lighting, rain, hail, and high winds. The storm toppled the Hall of Transportation, and the entire building shifted and collapsed.

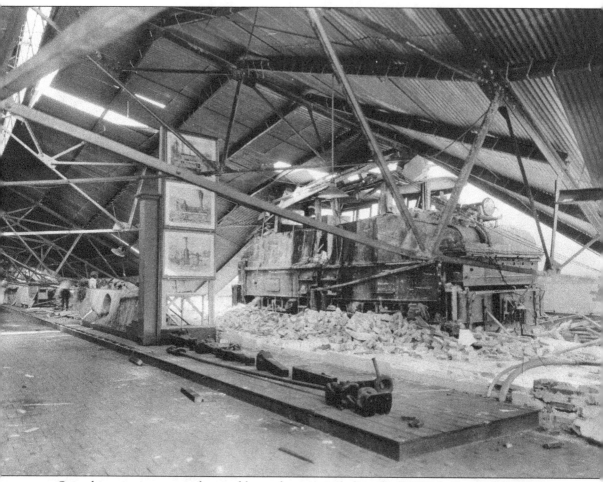

Some historic pieces were damaged beyond repair, including the B&O's first main line electric locomotive, No. 1 (pictured here). The engine was placed in service in 1895. Built by General Electric, it operated through the Howard Street Tunnel for many years. Many of the historic engines were saved and sent to Bailey's Roundhouse near Camden Station; however, the B&O scrapped the electric locomotive.

Six

THE END OF AN ERA
1928–1986

From 1928 to the end of the B&O in 1987, the railroad faced significant challenges that mirrored the railroading industry. The first was the Great Depression, which forced changes in operations, layoffs, and increased competition. World War II created a brief resurgence due to the increased freight and passenger traffic related to the war effort. However, postwar challenges due to regulation and the increased use of trucks, automobiles, and airplanes siphoned off business, and the railroad began a rapid decline in the 1950s.

It was during this period that the railroad began transitioning to diesel power. The B&O began by adding a box cab switcher as early as 1925 and introduced No. 51, the B&O's first streamlined diesel engine, to pull the Royal Blue in 1937. The B&O was slow to transition to diesel technology due to labor opposition, implementation costs, and World War II's demand for any and every available engine, which extended the life of steam power. The Mount Clare Shops built its last steam engine in 1948, and by 1960, the B&O no longer operated steam on its line.

Following the war, passenger service entered a period of decline, as people relied more heavily on other forms of transportation that were often speedier and less costly than rail travel. Passenger service on the main line ended in the late 1940s, and service was reduced, eliminated, or modified on many B&O routes. Many stations closed their doors or served as freight-only terminals. The railroad would shed its passenger service completely in 1971 with the creation of Amtrak.

By 1963, financial losses proved too much for the B&O, and it merged with the Chesapeake & Ohio Railway. While maintaining separate corporate identities, change was in the wind, and B&O no longer controlled its fate. Merging again with the Western Maryland, the three entities would be known as the Chessie System in the early 1970s. Ultimately, they would merge with Seaboard and create CSX. The B&O would formally cease to exist in 1987.

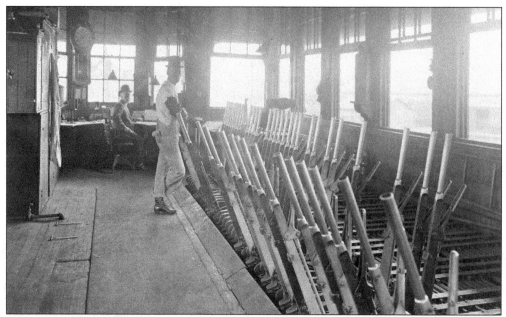

This interior view of the switching tower at Camden Station shows the telegrapher (rear) and the switchman, who hand-operated the switches necessary to maneuver trains in, out, and around the crowded stretch of tracks. Switching towers were efficient ways to change track alignments and allowed one individual to align tracks in a central location, rather than on the ground directly next to individual switches.

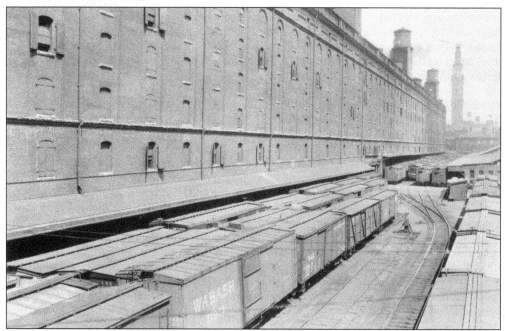

Freight cars wait for loading and unloading on the eastern side of the B&O's Camden warehouse. The tracks were frequently packed at this busy hub. In the distance is Baltimore's famous Bromo Seltzer Tower. The top of the tower contained a blue bottle of Bromo-Seltzer, which was removed in 1936 due to structural concerns. Like the warehouse, both structures still exist and are local landmarks.

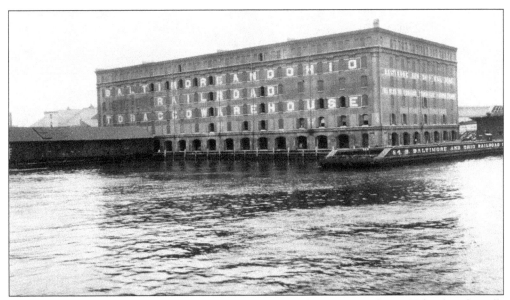

These photographs show the B&O Railroad's tobacco warehouse at Henderson Wharf on the Fells Point waterfront. Designed by Ephraim Baldwin, it was completed in 1898. It was six stories high and had the capacity to hold the contents of 500 freight cars. Southern tidewater tobacco was brought to the warehouse for classification and sorting prior to being sent to European markets. Kelly-Springfield rented the building for tire storage, and it was used to store other wares, including whiskey, into the 1970s. The above photograph shows the western side of the building as seen from the water. The photograph below, taken from the street side, is from the early 1930s. On the far left is the No. 10, an electric engine used to move boxcars for 45 years. The warehouse is now home to an inn and private condominiums.

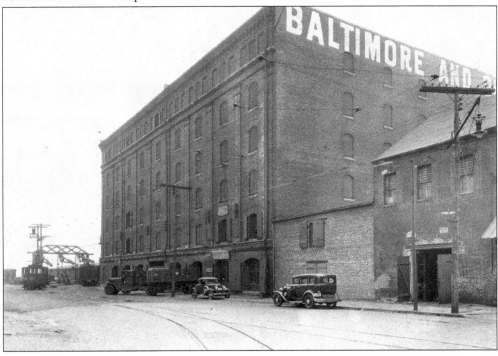

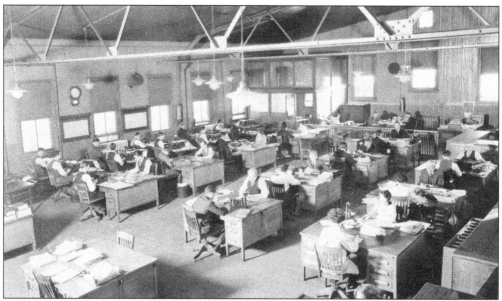

Shown here are contrasting views of the Camden warehouse operations. Above is a 1930s interior view of the freight offices of the B&O, housed in the upper floor of the warehouse. Below are hundreds of barrels of rye whiskey awaiting shipment. Since the earliest days of railroading, hauling freight has always been the main money-making venture of railroads. The warehouses held every kind of product shipped by the B&O. Operations like these were significant, financially lucrative, and helped make the port of Baltimore a major business hub.

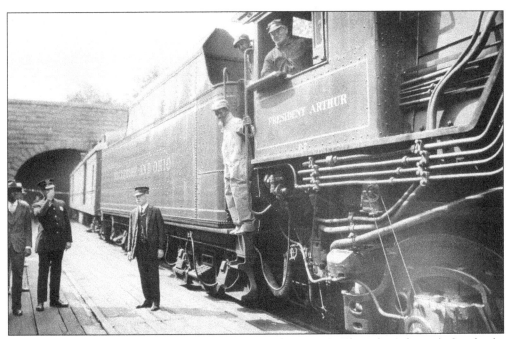

Pictured here are two envoys from the emperor of Abyssinia (modern-day Ethiopia). On the far left is Kentiba Gabru, and on the steps of the *President Arthur*, dressed as a fireman, is Malaku Bayen, a relative of the emperor. Both men rode the Capitol Limited from Washington, DC, to Baltimore's Mount Royal Station on August 27, 1930.

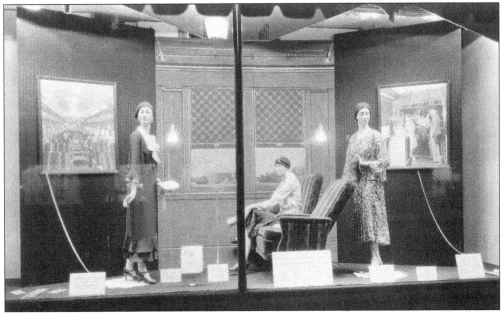

The B&O used window displays at Hochschild Kohn & Company's Baltimore department store to promote its history and services. This May 1931 display was used to promote the comfort and amenities of the B&O's new passenger coaches. The coaches featured individual wall lights for night reading, window ventilators that allowed fresh air to come in without the dust, and reclining passenger seats with footrests.

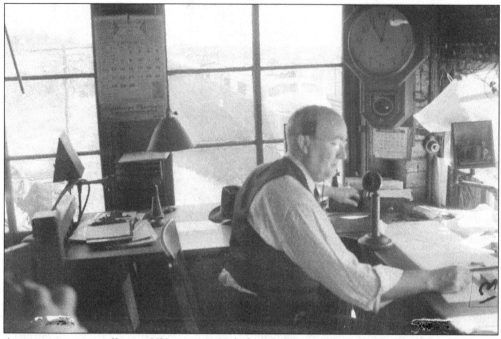

A passenger train pulls past HX tower in Halethorpe, Maryland, in November 1938. The tower was built in 1917 and served the bustling site of the Fair of the Iron Horse during the 100th anniversary celebration in 1927. It controlled southbound and westbound traffic along the main line. Located just east of Halethorpe Farms Road, the tower closed in 1985.

This iconic image of B&O crewmen appeared in B&O's magazine in October 1930. Shown here are, from left to right, conductor C.J. Welch, brakeman Mort Yarnell, and baggage man Roy Durrett. Taken in Grafton, West Virginia, the image is included here because the crew operated between Grafton and Cumberland. The magazine marveled, "They make traveling between Cumberland and Grafton a pleasure all the time."

Passengers waiting to board B&O trains spend their time relaxing in Mount Royal Station. With high ceilings, large windows, ornate columns, marble floors, a fireplace, and incredibly comfortable rockers, the station could boast a beautiful decor. Service at the station ceased in the early 1960s. The building was saved from demolition and decay when it was sold to the Maryland Institute College of Art in 1964 for $250,000.

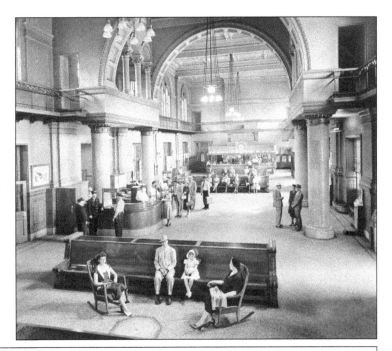

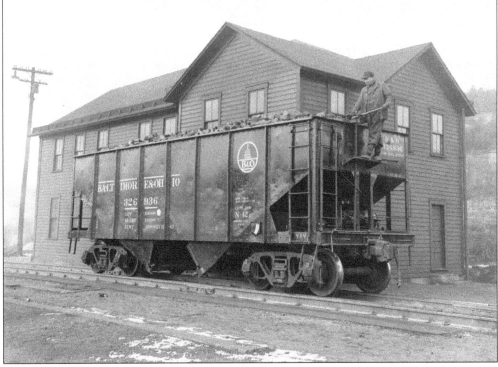

A brakeman handles a 50-ton coal hopper in the Cumberland classification yard. Brakemen had very dangerous jobs, riding railcars and adjusting hand brakes in all types of weather. While air brakes helped make this less necessary on main line service, brakemen still rode cars in hump yards as the freight trains were broken apart and reformed. Here, the brakeman inserts a bat in the hand brake for more leverage.

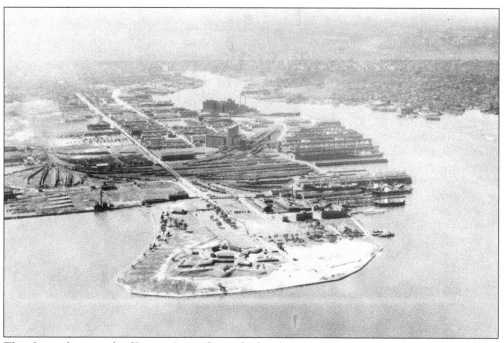

The above photograph of Locust Point shows the bustling facility in the 1930s. In the distance is the industrial, business, and commercial center of Baltimore. In the foreground is Fort McHenry. The bombardment of the fort by the British in September 1814 served as the inspiration for Francis Scott Key to pen "The Star-Spangled Banner." In addition to people, grain, coal, ore, and bananas were loaded and unloaded at Locust Point. Below, a worker unloads at the Locust Point fruit pier. The Locust Point operation prepped refrigerator cars and loaded barges that traveled to Pier No. 1, located in Baltimore's Inner Harbor (known as the basin). The B&O operated a special train between Baltimore and Toledo, Ohio, that would run any day it had 25 cars to move.

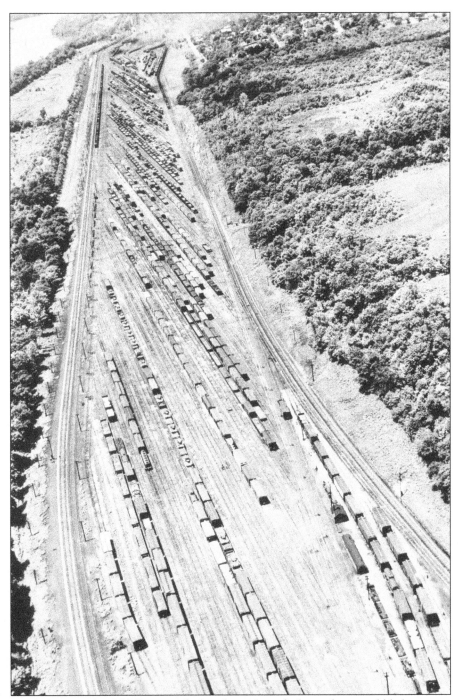

This aerial photograph of the Brunswick classification yards shows the incredibly large operation that stretches seven miles along the banks of the Potomac River in Frederick County. Opened in 1890 to ease crowding of the Martinsburg rail yard in West Virginia, the yard and facilities provided the space needed for breaking and building freight trains and for servicing engines. The geography was ideal for rail operations, and the land in the area was relatively cheap. The yards are still in use today.

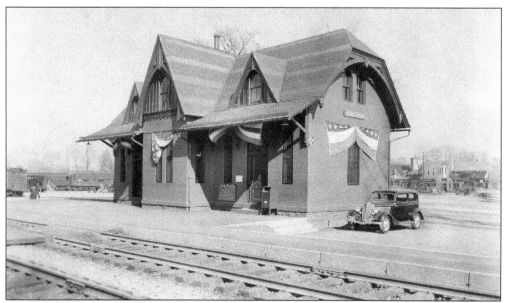

Silver Spring, Maryland, has been home to two B&O passenger stations. The first, constructed in 1878, is pictured above in the late 1930s. This two-story, High Gothic structure was designed by Ephraim Baldwin and was similar to the 1873 station built in Rockville, Maryland. The location of the station was, in part, determined by the efforts of Washington newspaper editor Francis Blair, who advocated the site based on early surveys of an uncompleted rail line. Below is the modern station, built in 1945. It replaced an existing 1878 station, and it was constructed directly on the foundation of the earlier building. Built in the Colonial Revival style from standardized station plans, the brick structure contained a waiting room, baggage room, and offices. The main station is owned and managed by Montgomery Preservation, Inc.

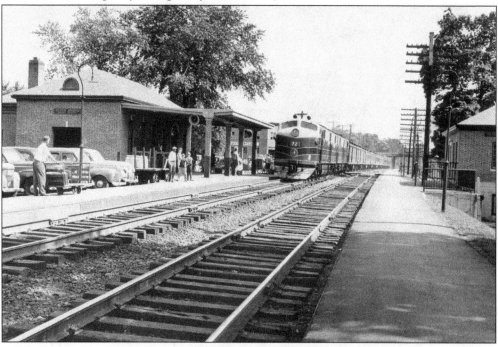

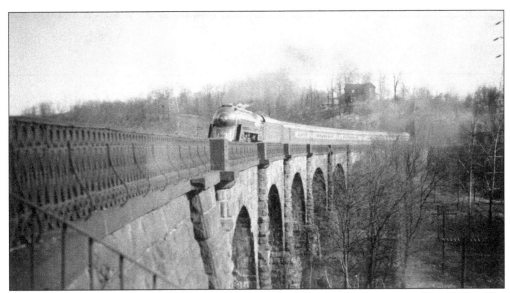

The Royal Blue heads to Washington, DC, over the Thomas Viaduct in the late 1940s. The streamlined locomotive is the Pacific class No. 5302, the *President Jefferson*. Built in 1927, it was streamlined in 1946 and retired in 1956. Like most of the presidential steam engines, No. 5302 was scrapped. In the distance is the Relay Hotel.

B&O SW-1 Switcher No. 208 pulls freight cars down Eutaw Street on the western side of the B&O freight warehouse in the 1940s. Construction of the warehouse began in 1898, and the last sections were completed in 1905. The eight-story building is over 1,000 feet long and 51 feet wide. The warehouse was saved from demolition when it was incorporated into the design for Oriole Park at Camden Yards.

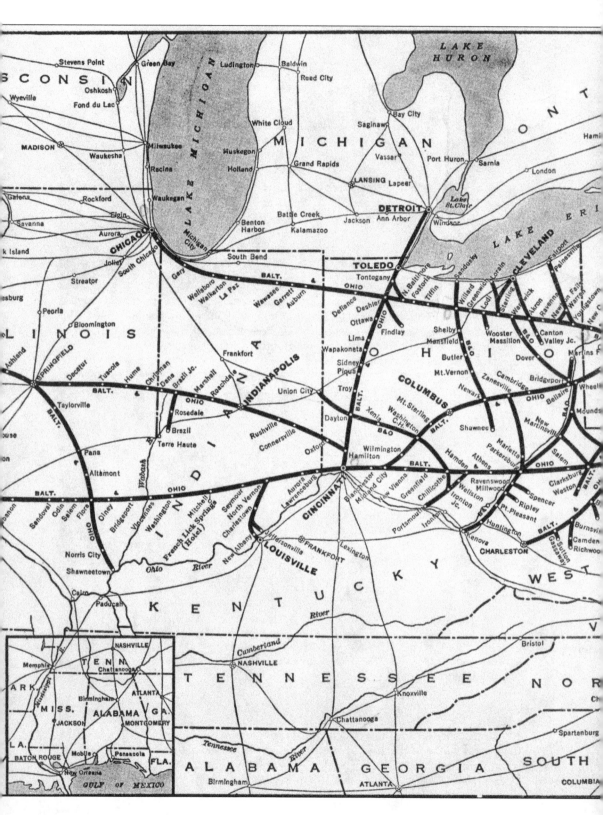

90

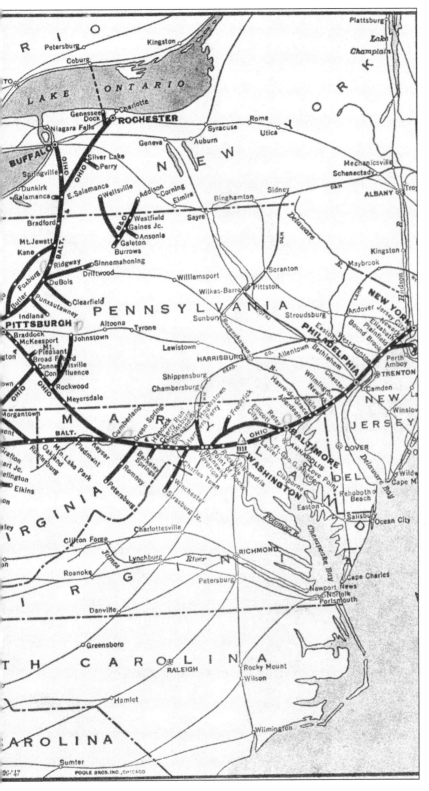

This map shows the extent of the B&O Railroad in 1954. It would be nine short years before the decline of the B&O picked up speed. Facing mounting financial shortfalls and declining business due to regulation and competition with trucks and airplanes, the B&O came under the control of the Chesapeake & Ohio Railway in 1963. While the two railroads maintained separate identities, mergers with the Western Maryland Railway created the Chessie System in 1972. Eventually, in 1987, the Chessie System merged with Seaboard to create CSX, and the B&O Railroad ceased to exist after 160 years.

A group of children gathers at the St. Denis station just outside Baltimore. The building, a simple Baldwin design, was typical of many of the standardized structures erected by the B&O in the late 19th century. Built in 1891, it burned down in 1976. A small shelter serves as a commuter stop on the MARC system where this station once stood.

Fearless Williams worked for the B&O Railroad from 1906 to 1952. He began as a floor porter at the General Office building. His dedication and abilities helped him earn a position in the president's office in 1916, where he served until he retired at the age of 70. He was active in Baltimore's African American community and was the maternal uncle of Supreme Court justice Thurgood Marshall, who also briefly worked for the B&O.

The B&O ran seasonal excursions to western Maryland to support the region's tourism. Here, a crowd gathers at the Oakland station to welcome visitors during the Autumn Glory Excursion on October 5, 1952. The excursions departed from Camden and Silver Spring, and buses provided transportation to local attractions and state parks before returning visitors to their point of departure. These trips allowed visitors to enjoy the crisp temperatures and beautiful scenery.

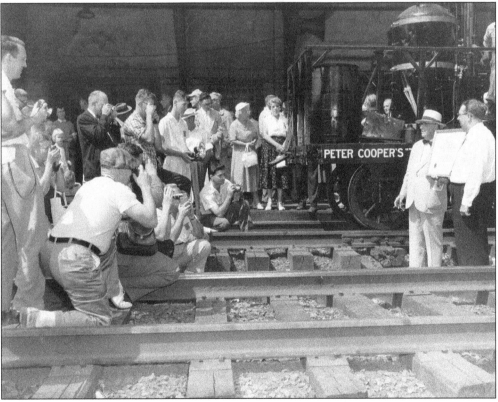

Lawrence Sagle (right, in hat), of the B&O's public relations department, accepts a certificate commemorating the 125th anniversary of Peter Cooper's Tom Thumb from Allan Constance (far right) of the Baltimore Society of Model Engineers. The presentation took place in 1955 on a trip down the main line during the Baltimore Convention of the National Model Railroad Association. Sagle would later head the B&O Transportation Museum.

The B&O dining car department operated a cafeteria on the 12th floor of the Central Building in Baltimore. In 1959, the cafeteria served an estimated 500 people every day. The facility operated from 7:30 a.m. to 8:30 a.m. for breakfast and from 10:30 a.m. to 2:30 p.m. for lunch. Helen Schubert serves coffee to Henry Horn, from the freight traffic department.

The B&O employed one of the latest innovations for car reporting in March 1959. The railroad introduced a system known as "D-O-T," or Data-on-Tracing. The system used punch cards to represent freight trains on the rails. That information was translated to teletape and sent by Teletype to the B&O's Baltimore nerve center. Here, Joan Bartenfelter supervises transmission of car information from tape to punch cards.

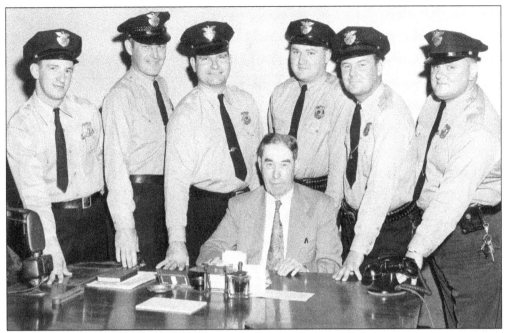

Guarding the railroad was a full-time job, and the B&O had its own dedicated police force. Pictured here are members of the B&O's Brunswick Police Department. Seated at center is Lieutenant McGaha. Standing are, from left to right, road patrolmen B.B. Burch and W.A. Cage; patrolmen W.D. Horman and W.R. Donovan; and relief men H.F. Carey and P.F. Weitzel.

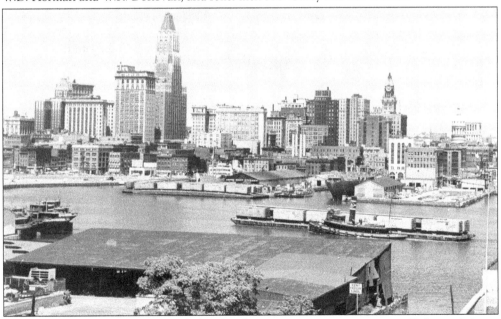

A B&O tugboat pushes a barge loaded with refrigerator cars into position near Baltimore's Inner Harbor. The United Fruit Company was located on Pier No. 1, where boats carrying bananas were unloaded and the produce transferred to the refrigerated boxcars. The B&O used barges to transfer the reefer cars from Locust Point to the Pier No. 1 facility for loading and unloading and then back to Locust Point for transfer and distribution by train.

95

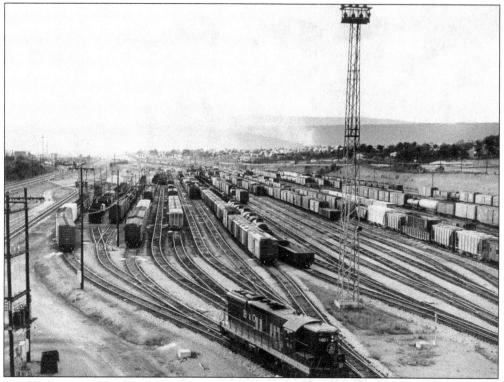

The B&O's Cumberland facilities were important for rail operations for freight as well as passenger service. Initial freight operations were located near the Queen City Hotel and station. As freight traffic grew, it became necessary to expand the operation to include a larger classification yard and hump operations. Here, a B&O SD-9 roadswitcher works the yard in the late 1960s.

B&O biochemist Carl Webster (seated) and Earle Heinbaugh test springwater for chlorine content near Deer Park. Land near the B&O's hotel contained a freshwater spring that was a source of clear water. The B&O bottled the water and used it for hotel guests and on its passenger trains. The railroad sold the spring in the 1960s to a company that continues to produce Deer Park water today.

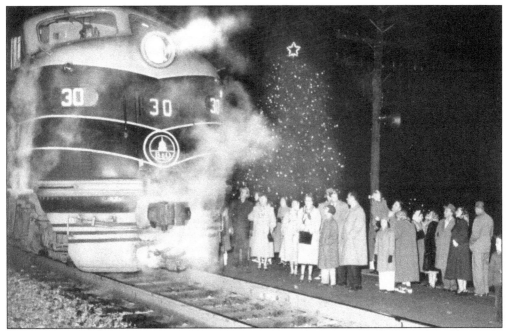

Visitors wait to board a train to Baltimore after visiting the B&O's Holly Tree along the tracks near Jackson, Maryland. The B&O purchased the tree, and volunteers decorated it annually. Lighting the tree became a seasonal event. As many as 55,000 people visited the tree during the holiday season, and countless travelers saw it as they passed by on B&O trains.

This image shows Baltimore's changing landscape, as redevelopment of the Inner Harbor begins in the 1970s. This area, located at the corner of Pratt and Light Streets, would become a collection of shops and restaurants known as Harborplace. To the left are Pier No. 1 and the USS *Constellation*. The pier was once home to B&O barges that served the operations of the United Fruit Company.

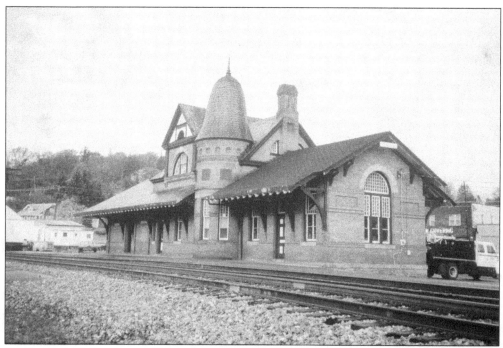

Designed by B&O architects Ephraim Francis Baldwin and Josias Pennington and built in 1884, the Oakland station was one of many significant improvements along the B&O line in the 1880s. Designed with two separate waiting rooms and a ticketing area, the building's Queen Anne style is symbolic of the B&O's efforts to upgrade its existing stations. It served the resort area of western Maryland and still stands today. Efforts are under way to open the site as a museum.

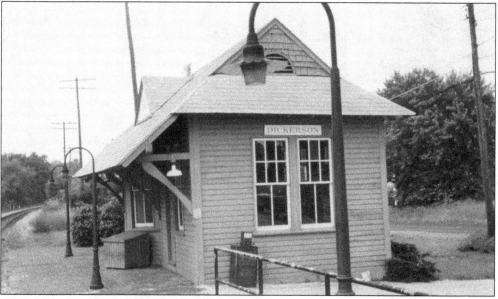

The MARC commuter station at Dickerson, Maryland, is a reconstructed version of the B&O station built in the 1890s. It was named for William Dickerson, who built a general store to serve the railroad contractors working on the line nearby. It was partially destroyed by fire in the 1970s and restored to its current appearance.

Seven

THE MOUNT CLARE SHOPS
1828–1992

The Mount Clare Shops constituted a self-contained industrial city capable of supporting almost every facet of the B&O Railroad. It was the nerve center of one of the most important railroads in America and the site of many railroad firsts as well as the location of the origin of Samuel More's first telegraph message. Located in west Baltimore, the shops were situated on a portion of an estate owned by James Carroll in 1828. He was a descendant of Charles Carroll the Barrister, a distant relative of Charles Carroll of Carrollton. From humble beginnings, the site would grow to become one of the largest employers in the city.

The shops evolved over time, based on need, and contained one of the first railroad depots in America. Buildings would be added, and eventually, the site would grow to include blacksmith, brass, and foundry shops; passenger car shops; machine shops; bridge-building facilities; locomotive-erecting and boiler shops; air brake shops; a grain elevator; and diesel-erecting shops. Several engine and passenger car roundhouses were added over time, including the sole surviving roundhouse on the site, designed by E. Francis Baldwin in 1884.

The decline of the shops mirrored the fortunes of the B&O. The last steam engine was built on-site in 1948, and fire destroyed the locomotive-erecting shops in 1962. Shortly after this, the B&O merged with the Chesapeake & Ohio Railway, and many functions would be moved to other facilities. By 1976, many of the buildings were unused and in poor condition, and they were demolished as the railroad downsized and eventually sold portions of the property.

Today, several buildings survive and form the core of the B&O Railroad Museum, including the Mount Clare Depot (1851), the passenger car roundhouse (1884), the annex (1884), the passenger car shops (1869–1870), and the freight-car repair shop (1919). Two buildings are in private hands, including the old mill complex (refurbished in 1908) and the test shop (rebuilt in 1924). The legacy of the shops continues, as the museum operates, maintains, and restores locomotives and rolling stock on the property. It is one of the oldest continually utilized rail facilities in the nation.

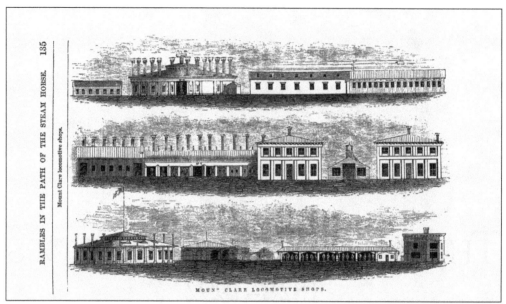

Mount Clare locomotive shops.

MOUNT CLARE LOCOMOTIVE SHOPS.

Shown here are the Mount Clare Shops as they appeared on the eve of the Civil War. This illustration comes from Eli Bowen's *Rambles in the Path of the Steam-Horse*, published in 1855. The shops had grown to become an industrial city capable of meeting and producing almost all of the railroads needs.

Located on the west end of the B&O Mount Clare property were brick engine houses situated at a 45-degree angle to the railroad's track. The area was referred to as "Russia," due to its remote setting. The buildings housed freight and passenger engines ready for service. The engine on the left appears to be one of the B&O's famous Camel locomotives.

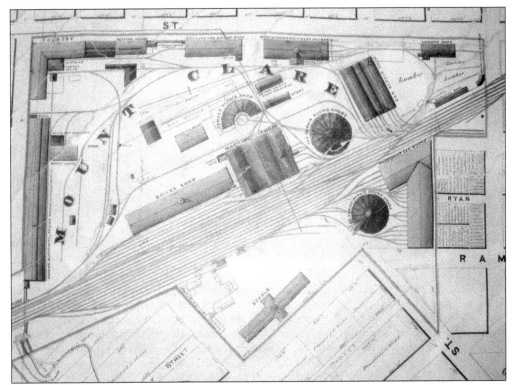

The map (above) shows the Mount Clare Shops in the early 1870s. It is incredible for the level of detail it provides, listing buildings and their functions. Most of the buildings and roundhouses no longer exist. The photograph below looks south across Pratt Street and shows the shops at approximately the same time. The building on the far left is one of the "half arrow" passenger car shops, located on the map's right-hand side and labeled "Passenger Car Works." The present-day roundhouse had not yet been built; its current location is the site of the lumber shed and yard in the foreground of the photograph and in the upper-right corner of the map.

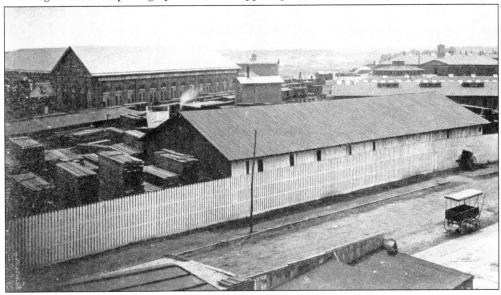

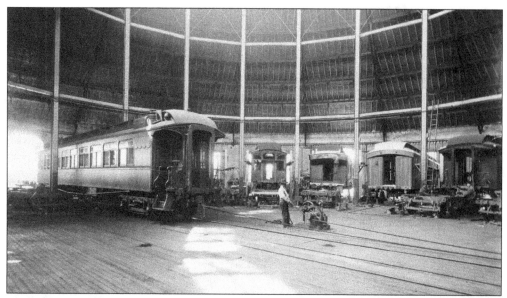

These photographs show the interior of the 1884 passenger car roundhouse, now home to the B&O Railroad Museum. In the above photograph, an employee pulls a passenger coach onto the turntable using a chain-and-pulley mechanism. Built to accommodate the B&O's passenger coaches, the turntable was 60 feet in diameter. Below, workers use a crane to lower a truck assembly onto a set of passenger car wheels. The railroad could assemble passenger coaches, from the wheels up, inside the 22-bay building. The facility would become outdated by the late 1920s, when the B&O began manufacturing 80-foot-long passenger cars.

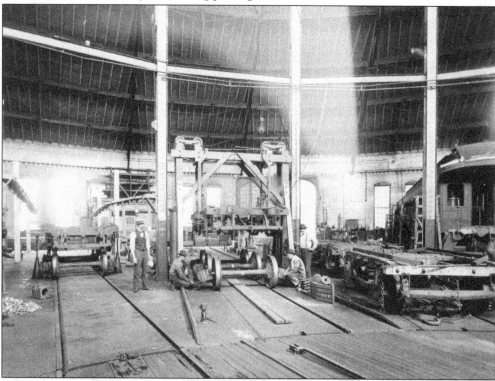

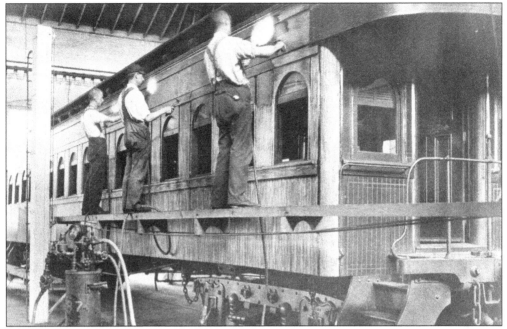

Employees use heat to soften and then scrape paint from the side of a passenger coach in preparation for repainting. The poles with wooden planks stretched between them served as scaffolding to allow work on the sides of the passenger cars at any height. The scaffolding system had adjustable pulleys that allowed the height to be easily set.

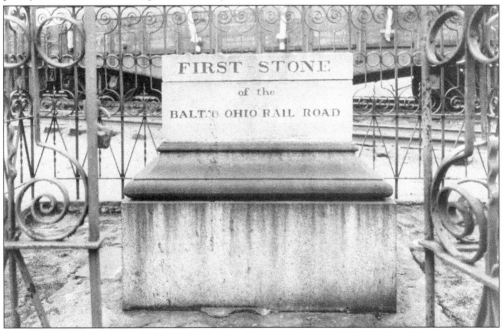

Lost to memory for many years, efforts were made to locate the first stone in the 1890s. It was found buried six feet underground. The stone was removed from the ground and placed on a marble pedestal and surrounded with a steel enclosure. Eventually, it would be removed and placed on display at the B&O Railroad Museum, where it remains to this day.

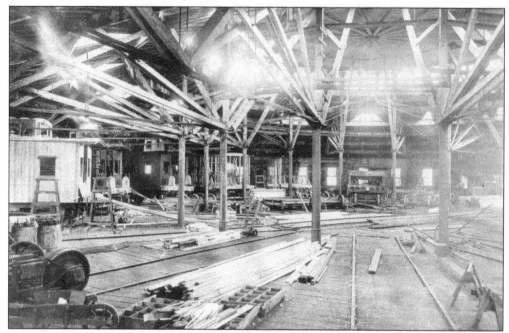

This c. 1900 photograph shows the interior of one of two smaller roundhouses located at the Mount Clare Shops. Several B&O wooden bobber cabooses are in various states of assembly. The roundhouse's clerestory level allowed light and ventilation, and a small turntable in the center allowed the cars and wheel assemblies to be pushed into the appropriate bay for work.

An interior view of the air brake shop in 1915 shows a table loaded with control handles and valves for steam engines. Invented by George Westinghouse in 1868, air brakes revolutionized railroad safety. Air brakes allowed the engineer to control braking from his seat, and valves located in the caboose allowed the conductor to apply the brakes in an emergency.

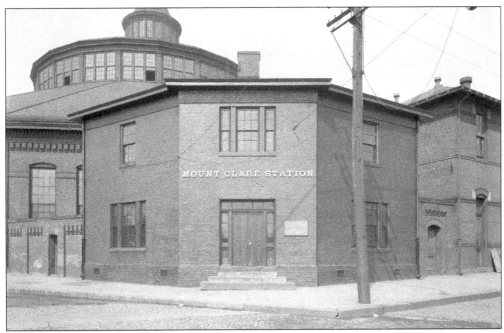

The historic Mount Clare Station and B&O's passenger car roundhouse are seen here in the 1920s. Located on the corner of Poppleton Street, the station dates to 1851. It replaced a wooden structure on the site that had been used for passenger and freight service. The plaque on the building erroneously claims the station was built in 1830; however, subsequent research clearly proved this was not the case.

Located behind the roundhouse was an air-conditioning test shed. The building was 90 feet long and 28 feet wide, long enough to allow a passenger car to be brought inside for testing. The B&O was the first railroad to experiment and install air-conditioning on its coaches, in 1931. The shed was constructed in the early 1930s and was still in place in the 1950s.

Workers at the Mount Clare Shops tighten the bolts holding an arch-bar truck together on a B&O boxcar sometime in the 1930s. Not all railroad jobs were as glamorous as the engineers or conductors, as this photograph shows. The use of wooden boards to stay dry shows a good bit of ingenuity on the part of the workers, performing an otherwise thankless but necessary job.

B&O employees test the strength of a rail at the Mount Clare Shops. Quality control and constant review were important for safety as locomotives and rolling stock grew in size and weight. Rail defects and failure, caused by a variety of reasons, including manufacturing problems, inadequate design, or wear, could have deadly results.

Mount Clare workers use compressed air to tighten bolts on the joint bar connecting two sticks of rail. The unique frame mounted on railroad wheels contains an I-beam that supports and holds the heavy weight of the rotary machine used to tighten the bolts. The Mount Clare passenger car repair roundhouse is in the distance.

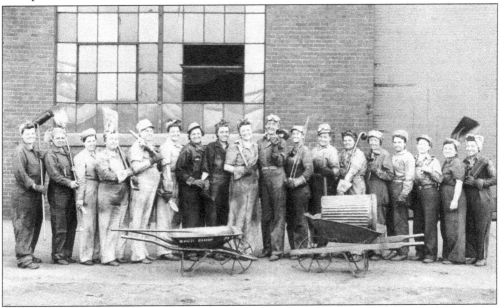

Female workers from the Mount Clare Shops pose with their tools. During both world wars, the B&O hired women to work in what were typically male occupations. They worked in the shops, as machinists, on rivet crews, and on track gangs, in addition to more traditional roles as station maids, car cleaners, telephone operators, and office clerical workers.

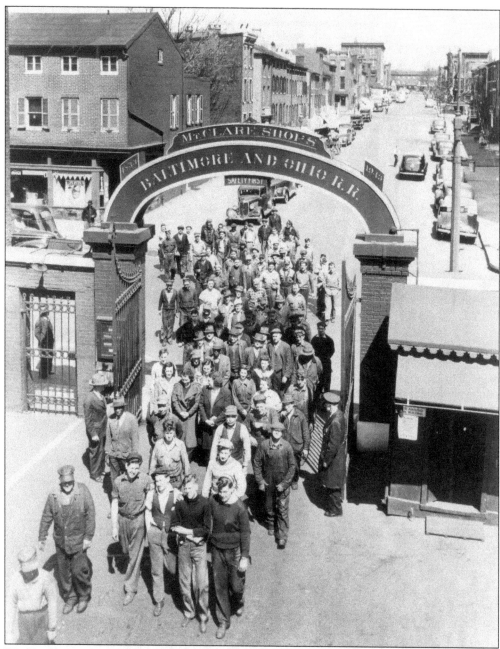

Workers file past B&O police at the railroad's main gate on Arlington Avenue. This 1943 photograph is likely a public relations product. During the height of World War II, the B&O benefited from the increased demand for military hardware and other supplies, which spurred an upturn in the American economy and an increase in rail traffic. In order to help the B&O and other railroads cope with an increase in demand and a shortage of labor, many workers pushed back or returned from retirement, and women were hired in increasing numbers to fill the gaps. The gate served as the main entrance to the site for countless generations. Images of the entrance can usually be dated because the railroad changed the year on the sign above the gates. The metal gates still exist and are in storage at the B&O Railroad Museum.

Mount Clare workers strip down a Mikado locomotive prior to a major rebuild. Baldwin Locomotive Works built the first Mikado 2-8-2 locomotives for shipment to Japan around 1900. Many of the B&O's Mikado locomotives dated to the 1910s and were rebuilt in the 1940s. This extended the service life of equipment that was 40 or 50 years old. The engines continued in service until the mid-1950s.

Constructed in 1910, the grain elevator at the Mount Clare Shops is shown here in the 1940s. This towering building dominated West Baltimore's skyline for years and served as a loading point for bulk transportation in B&O freight cars. It also served as a photography platform, providing a bird's-eye view of the shops. It was dismantled in 1976.

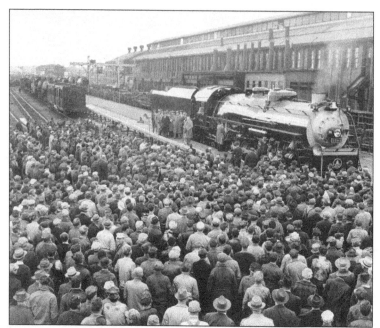

This celebration marks the completion of the 40th, and last, T-3 locomotive to enter service on the Baltimore Terminal Division. Almost 2,000 workers joined B&O president Roy B. White and company officials for the send-off. The rally took place on October 18, 1948. The No. 5594 was dropped from the company roster in 1956, only eight short years after entering service.

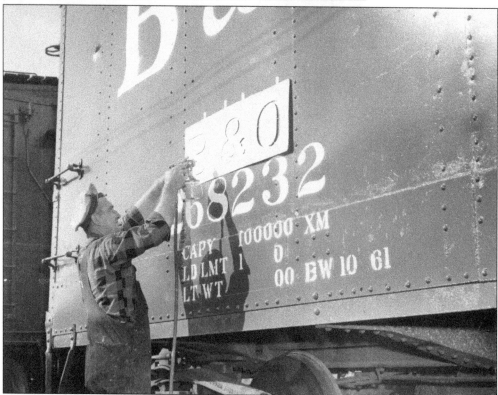

A painter stencils "B&O" on the side of a freight car using an air-gun sprayer. Stenciling and painting a railcar was a skill. Stencils were handmade from cardstock and metal wire and were taped or held in place while the paint was applied. Even with the advent of air-powered sprayers, car lettering was still done by hand well into the 1940s and 1950s on some B&O passenger cars.

Shop workers performed a variety of tasks on freight and passenger cars at the Mount Clare Shops. Here, two employees lower a truck assembly onto a set of wheels in the late 1950s. They are aligning the assembly by using the journal box covers to push and guide it into place.

Located on the eastern end of the locomotive-erecting shop was the smaller diesel-erecting shop. The 300-foot-long shop provided maintenance facilities for a growing fleet of diesel engines. It contained cranes capable of lifting locomotive bodies or replacing diesel engines. Diesel technology first appeared on the B&O in 1925 and would eventually spell the end to the steam era, as diesel locomotives proved more cost-effective to operate and maintain.

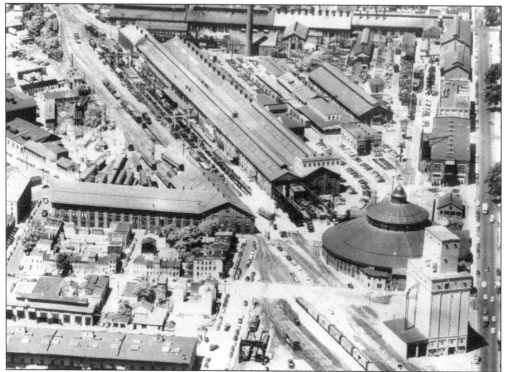

This aerial photograph of the Mount Clare Shops looks west in 1953. The site is seen prior to its decline in the 1960s and 1970s. At lower right is the grain elevator and the 1884 roundhouse that housed the newly opened B&O Transportation Museum. At center, positioned diagonally, are the machine and locomotive-erecting shops. The L-shaped buildings to the left are the passenger car shops.

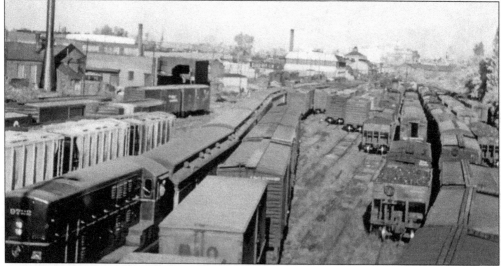

Pictured here are the bustling tracks of the Mount Clare yards, looking east toward Baltimore in the late 1950s or early 1960s. The diesel engine on the left is a Fairbanks Morse H12-44 switcher, built in 1957. No less than 10 tracks at this point in the yards are occupied by both freight and passenger cars. The roundhouse and car shops can be seen in the distance.

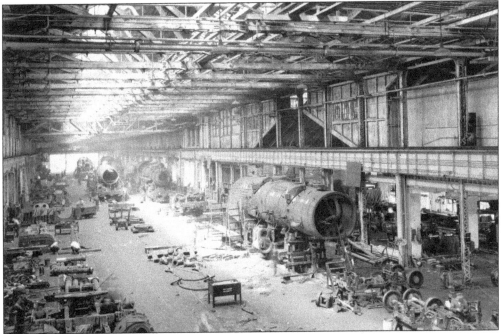

The above photograph provides an incredible view of the interior of the locomotive-erecting shop, also known as the boiler shop, during the heyday of steam in the 1920s. At least five steam engines are being serviced in this huge structure, which stretched over 1,000 feet. Located behind the present-day roundhouse, the building expanded to cover a significant part of the shop property. Large windows allowed additional light into the building, and an overhead crane was one of two 80-ton cranes that provided massive lifting power. The erecting shops burned down in 1962, gutting the figurative heart and soul of the B&O's operations. The C&O Railway purchased the B&O in 1963, and while the shops continued to function, the erecting shops were not rebuilt.

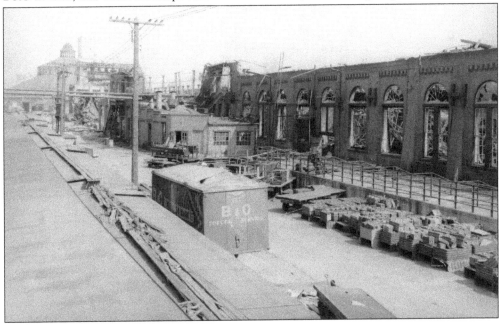

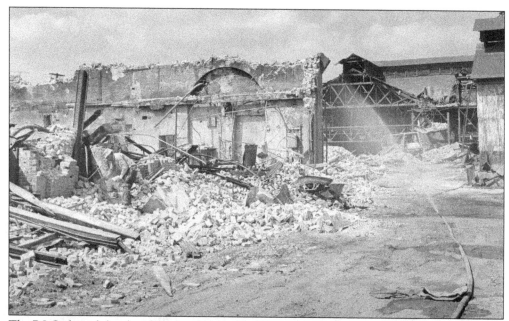

The B&O cleared the abandoned and unused buildings in 1976. Here, the wreck cranes demolish a portion of the foundry on the corner of Pratt and Carey Streets. The only historic structures to survive demolition were the roundhouse (1884), annex (1884), Mount Clare Station (1851), the north and south passenger car shops (1867), the sawmill (rebuilt in 1908), and the office building and test shop (rebuilt 1924).

This photograph looks northeast across the Carey Street Bridge after the majority of the old shop buildings had been cleared in 1976. Gone are the brass foundry, iron foundry, and the blacksmith shop that lined the street, all dating to the 1860s. The site is currently home to a shopping center called Mount Clare Junction.

Eight

THE B&O
RAILROAD MUSEUM
1953–TODAY

The B&O Railroad Museum exists on the hallowed grounds of the B&O's Mount Clare Shops. Widely recognized as the birthplace of American railroading, it consists of five historic buildings on 40 acres in west Baltimore. The museum contains the oldest and most comprehensive collection of railroad artifacts, locomotives, and rolling stock from the beginning of US railroading through today.

The gem of the B&O Railroad Museum is the 1884 passenger car roundhouse, which opened as the Baltimore & Ohio Transportation Museum on July 4, 1953. The core of the collection on display in the roundhouse can be traced to the late-19th-century efforts of "Major" Joseph Pangborn, hired in 1880 to promote the railroad. He saved many aging locomotives for exhibit at the World's Columbian Exposition in Chicago in 1892–1893 and the 1904 Louisiana Purchase Exposition in St. Louis. The success of these exhibitions led the railroad to save and store its collection in Martinsburg, West Virginia. They would be displayed again in 1927, during the 100th anniversary celebration of the B&O known as the Fair of the Iron Horse. The fair's site was intended to become a museum; however, the Great Depression and a severe storm devastated the grounds.

Many of the historic locomotives and rolling stock were kept in storage until 1953, when the B&O Railroad placed them on display at the newly opened museum with great fanfare. It faced a difficult future due to financial issues associated with the decline of the B&O. Ultimately, mergers would force the end of the B&O in 1987. However, efforts of dedicated corporate officials, like the Chessie System's Hays T. Watkins and then Baltimore mayor William Donald Schaefer, ensured its survival. In 1990, CSX, the ultimate successor of the B&O, cut ties with the museum, which began operation as a nonprofit.

Today, the museum continues to collect, preserve, and present the history of American railroading, with an emphasis on the B&O, C&O, Western Maryland, and other mid-Atlantic railroads. It is a National Historic Landmark, a Smithsonian Institute affiliate, and an award-winning educational institution. Dedicated to bringing history alive, it continues to be a national treasure.

Members of the Women's Passenger Association gather at the historic first stone during their visit to the B&O Railroad Museum in September 1957. The group's visit was highlighted in the employee magazine, as local B&O employees led the tour on an evening that featured dinner at the Lord Baltimore Hotel, a discussion on the B&O's historic train fabrics, and ended with a tour of the museum.

Lawrence Sagle, B&O public relations representative and curator of the B&O Transportation Museum, is interviewed by Mac Edwards on local Baltimore station WJZ-TV in October 1957. The Imlay coach *Ohio* serves as the backdrop for a segment featuring the museum's exhibits. The Imlay cars were reproductions of some of the earliest passenger cars used on the railroad.

Visitors enjoy the museum's HO-scale model train layout, located on the upper floor of the annex. Designed by Lawrence Sagle, it was built in 1956 by Ken Henry, Emil Elliott, Bill Sakers, and George Baldwin. It contained a small town, a portion based on the B&O's main line near the famed Magnolia cut-off, and a section with train-service facilities. The layout was removed from display in 2003.

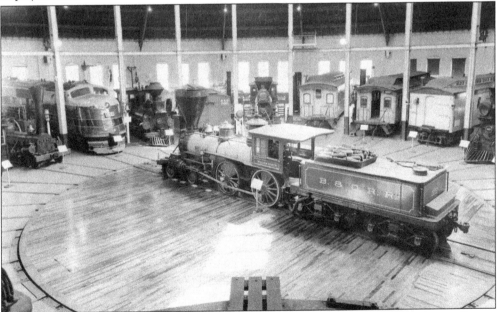

The *William Mason* sits on the turntable in these undated images inside the museum's roundhouse. The roundhouse has always been used to house the most significant pieces in the museum's collection and contains the most extensive collection of 19th-century locomotives and rolling stock dating to the beginning of railroading. Built in 1856, the *William Mason* is an "American-type" locomotive and is the oldest operating steam engine in the country.

Charlie Carroll cleans the No. 600 *JC Davis* at the B&O Railroad Museum in 1957. Built in 1875, the engine was designed by J.C. Davis, the B&O's master of machinery. Due to the power and success of the railroad industry, these locomotives were known as "moguls." Originally, the moguls were designed for freight service; however, Davis also decided to use the powerful and versatile locomotives for passenger service. During the nation's centennial in Philadelphia, the No. 600 was exhibited at the Maryland pavilion as a state-of-the-art steam engine. It won first prize for its attractive design and color scheme. During the Fair of the Iron Horse in 1927, it received a face-lift and was renamed after its creator, Davis. Severely damaged in the 2003 roundhouse roof collapse, it is currently undergoing restoration to return it to its 1875 appearance.

A group of Scouts enjoys a visit to the museum and stops for a photo opportunity on the handcar. The handcar provided track workers and railroaders with a self-propelled and relatively efficient means of traveling the rails. A single worker could power the car, or it could accommodate up to four and pull tool cars behind it. They would be replaced by motor-powered section cars.

Crowds gather around the B&O Railroad Museum's newest arrival, the Central Railroad of New Jersey's (CNJ) No. 592 "Atlantic Camelback." Built by the American Locomotive Company in 1901, it could travel at speeds of up to 100 miles per hour. The No. 592 pulled the jointly operated B&O's Royal Blue. In 1949, the No. 592 was retired from service, and it was donated to the Baltimore & Ohio Railroad Museum on May 4, 1954.

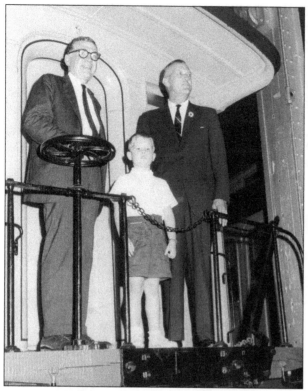

B&O president Jervis Langdon (left) and his son Halsey pose with Baltimore mayor Theodore McKeldin on the platform of a Civil War–era wooden passenger car in the museum's roundhouse in July 1964. They are celebrating the reopening of the museum after it had been closed for economic reasons from 1958 to 1964.

Built for express service on the Chesapeake & Ohio Railway in 1929, baggage car No. 314 is remembered for carrying the body of Pres. Dwight D. Eisenhower as part of his funeral train in 1969. The car was retired to the museum in 1971. The car was the centerpiece of a commemorative exhibit to honor the 10th anniversary of the president's death.

Visitors enjoy exhibits on the second floor of the museum's annex in the 1970s. On display is a collection of rare passenger car seats that illustrate their development. In the cases on the wall are examples of the museum's extensive collection of scale and model trains. On the wall above are lithographs of early steam engines. Today, this area houses the staff offices.

The lower floor of the annex contained exhibits on the early days of the B&O. On the far right is the first stone. In the gallery cases are models and artifacts, covering everything from Wendel Bollman's bridge to Imlay passenger cars. Mounted on the wall are Herbert Stitt's paintings on the history of the B&O.

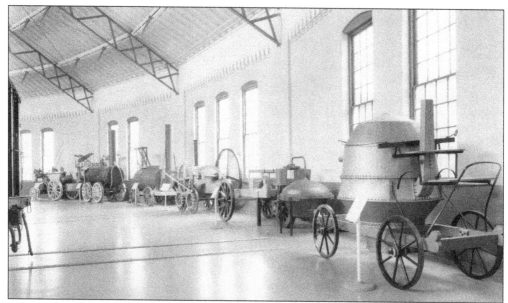

Exhibited in the roundhouse were the B&O's Pangborn models. Constructed for display at the Chicago Columbian Exposition in 1893, the wood models told the story of pioneering steam-locomotion technology. They were named after Joseph Pangborn, the B&O's first public relations director. At the time of the roof collapse in 2003, fourteen were displayed in the roundhouse; nine suffered severe damage.

Baltimore mayor William Donald Schaefer (left) poses in front of the *William Mason* with Chessie System chairman and CEO Hays T. Watkins, prior to the announcement of plans to renovate the museum in August 1973. Watkins's leadership was crucial for the survival, growth, and development of the museum. The facility would be closed for over two years for the renovations. When reopened to the public in 1976, the museum would be renamed the B&O Railroad Museum.

The museum's roundhouse and collection served as the backdrop for many of the activities during the celebration of the 150th anniversary of the B&O in 1977. These included an unveiling of B&O locomotive No. 1977, dinner at the B&O Railroad Museum, and the stockholders' annual meeting. Festivities also included the inauguration of the Chessie Steam Special, a six-month odyssey that carried 24,000 people, commemorating the history and heritage of America's first true railroad. In the above photograph, dignitaries and visitors gather for the celebratory dinner, held in the museum's roundhouse. They arrived via an Amtrak passenger train (left). In the distance is B&O GP40-2, painted in the Chessie livery and intended to show modern motive power. The photograph below of the stockholders' meeting was taken from the catwalk in the roundhouse.

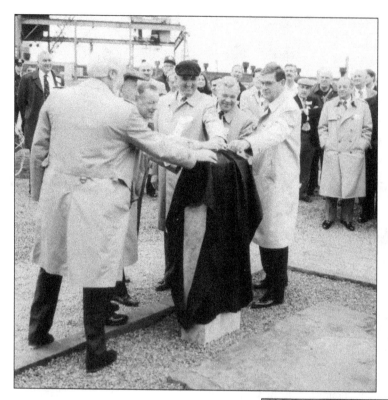

On March 18, 1992, Baltimore celebrated the transfer of property from CSX to the B&O Railroad Museum. The ceremony included the unveiling of a marker at the site of the first stone. Taking part in the festivities are, from left to right, the museum's executive director, John Ott; Maryland governor William Donald Schaefer; museum board member John T. Collinson; Pete Carpenter from CSX; Richard Leatherwood, president of the museum's board; and Jerry Davis from CSX.

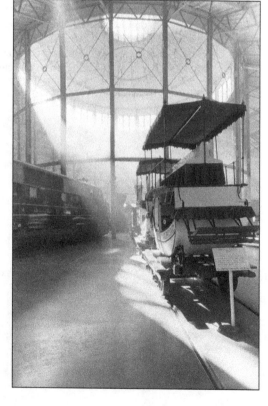

Visitors to the museum on a sunny day can appreciate the artistic beauty of the sunlight gleaming through the clerestory windows of the roundhouse. Here, the light shines on the B&O's historic Imlay coaches. To the left of the coaches is the EA No. 51, the B&O's first streamlined diesel engine.

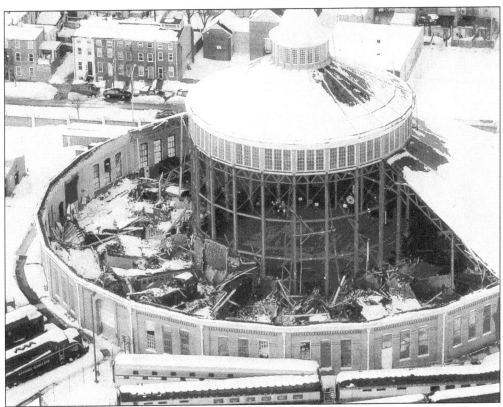

These photographs show the devastation caused by the roof collapse during a record-breaking snowstorm on February 16 and 17, 2003. A combination of factors led to the collapse, including heavy snow, the accumulation of large snowdrifts, the building's age, and the design of the roof. In the collapse, 11 roof panels from the 22-bay roundhouse fell, showering rare 19th-century locomotives, railroad cars, exhibits, and small artifacts with tons of wood, iron, slate, and snow. The collapse caused more than $30 million in damage. The above photograph, showing the extent of the damage from the air, was taken the morning after the collapse. Below, efforts to remove debris are under way in March 2003. Many of the locomotives and railcars had to remain in place during the rebuilding process due to damage to the turntable.

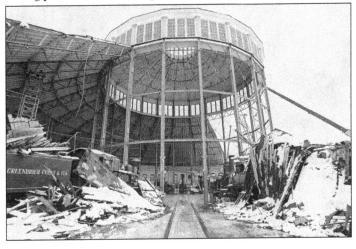

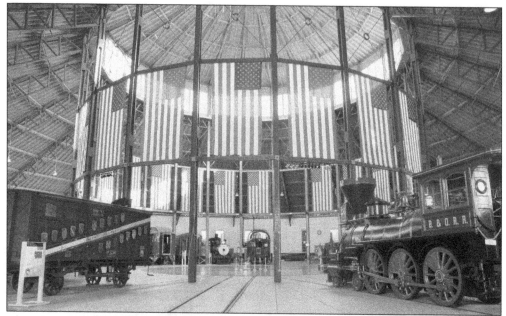

The museum was closed for 22 months during the rebuilding. But like the phoenix rising from the ashes, the institution made an astonishing recovery. It took the combined efforts of architects, engineers, contractors, and staff, provided with funds from insurance and all levels of government, as well as donations from around the world, to rebuild the roundhouse. It continues to be one of Baltimore's most popular attractions.

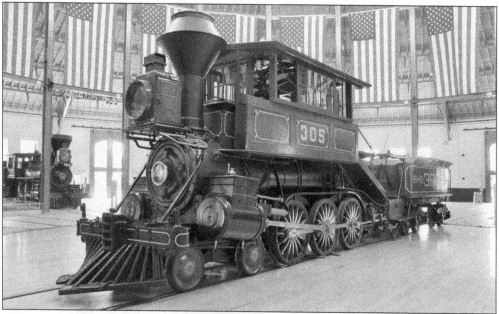

The roof collapse led to the construction of a state-of-the-art restoration facility to handle the repair of damaged equipment. Work on the historic engines requires extensive research and significant fundraising efforts. Here, the No. 305 Camel sits on the museum's turntable following several years of work. This locomotive was previously on display as the No. 217; however, following research, the engine was returned to its original number and appearance.

Today, the B&O Railroad Museum continues to bring the magic of railroading to life. Housing engaging exhibits and a world-class collection of locomotives and rolling stock, it documents the birth and development of railroading in America. Visitors of all ages can learn about the site's rich heritage, relive a bygone era, and make memories to last a lifetime.

Visit us at
arcadiapublishing.com

..